IMAGES
of America

LINCOLN

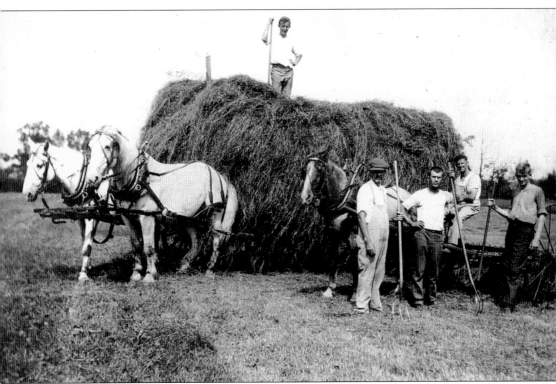

This 1920s view shows the Theinert brothers and their hired hands at the end of a long day of cutting, raking, and loading hay at the Theinert Farm. Standing on the heavily laden hay wagon is the elder brother, William Theinert. His younger brother Walter is seated on the horse-drawn hayrake. For decades, these two brothers and their father operated one of the largest and most successful farms in the town of Lincoln. Three hundred and fifty acres in size, the farm stretched from the west side of Old River Road to present-day Routes 146 and 295. (Gail Theinert Harris.)

IMAGES
of America

LINCOLN

Charles E. Savoie

ARCADIA

First published 2004

Published by Arcadia Publishing,
Charleston SC, Chicago IL, Portsmouth NH, San Francisco CA

Printed in Great Britain

Library of Congress Catalog Card Number: 2004102286

For all general information, contact Arcadia Publishing:
Telephone 843-853-2070
Fax 843-853-0044
E-mail sales@arcadiapublishing.com
For customer service and orders:
Toll-free 1-888-313-2665

Visit us on the Internet at www.arcadiapublishing.com

To Marie-Rose (Belhumeur) Savoie and Romeo Savoie.

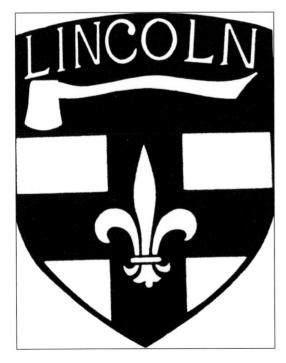

Town fathers chose this coat of arms for the new Town of Lincoln. The ax was placed prominently below the town's name because of President Lincoln's recognized reputation as a great rail-splitter. The fleur-de-lis centered on a red cross is a reference to Lincolnshire, England. The remaining decorations, a red background and gold edges, were applied to satisfy heraldic custom. (Town of Lincoln.)

CONTENTS

ACKNOWLEDGMENTS

The task of assembling this pictorial history of the town of Lincoln was accomplished through a collaboration of many individuals to whom I would like to extend my thanks. They include: the Blackstone Valley Historical Society (BVHS), Roger Gladu, Ted Bishop, Gail Theinert Harris, E. Paul Schwarze, Louise Schwarze, Andre Lavallee, Susan Darling, Daniel Bethel, Ida McDermott, the Lariviere family, the Lacroix family, Beatrice Durand, George Roy, Sue Sheppard, Dave Sale, Marie-Rose Savoie, Isabelle Maurice, Normand Dauphinais, Louise Carter, Rene Fortier, Claire Fortier, John Cullen, John Verdon, Kathey Hartley, John Scanlon, Friends of Hearthside, Everett and Esther Wilbur, Gordon and Barbara Jackson, Mike Hebert, the Rhode Island Department of Transportation (RIDOT), Tom Shanahan, Edgar and Gloria Sutherland, Charles Gauthier, Louann Noreau, Therese Desjardins, Al Klyberg, Edward Slattery, Larry Strezsak, Jason Dionne, Nancy Cragg, Win Randall, Raymond W. Houghton, Henry Langlois, Joyce and Jim Bethel, Marie Pelletier, Linda Church, Paolina Gatikova, Hope Tucker, Ann and Dick Buckley, Mr. and Mrs. Thomas Morris, Andy Poirier, Betsy Vose, Muriel Masse, Dr. George Kokolski Sr., Ed Whalen, and the town of Lincoln. All of these people and organizations contributed images or assisted me in the production of this book in some manner. It was truly a group effort. If I left anyone out, please accept my sincere apology as it was by no means intentional.

—Charles E. Savoie

One

THE NORTH WOODS

The North Woods and the Outlands of Providence were names given to the area comprising present-day Lincoln by Rhode Island's founding fathers. In 1636, Roger Williams negotiated the acquisition of vast tracts of land from the Narragansett Indian sachems (kings) Cannonicus and Miantonnomi. Though referred to as rocky, meadowless, and barren, the area was used by small bands of natives for hunting, fishing, and primitive agriculture.

For the next 30 years, only a few brave English souls ventured into this area, preferring instead to remain in the relative comfort and security of the town of Providence. By the 1660s, the presence of limestone deposits, fertile soil, and potential profit finally encouraged the first English settlers to spend more time in the North Woods.

After King Philip's failed Indian uprising in the 1670s, renewed Colonial interest in the outlands resulted in the creation of a great road. The c. 1683 Great Road and the North Woods continued to remain part of the town of Providence until 1730. By that time, public outcry over the inconvenience and difficulty of traveling to Providence to conduct town business resulted in the creation of the Town of Smithfield. The geographical area of present-day Lincoln was located in this town.

The 19th century brought the Industrial Revolution and with it political disagreement among the villages of Smithfield. The rural parts of town cared little for what was important to the mill villages in the eastern sections of Smithfield, and vice versa. They had few priorities in common. A town meeting in January 1871 resulted in plans to divide the town of Smithfield, and a number of new names were considered for the new town to the east. Some names were given more consideration than others; among those discussed were Lincoln, Lonsdale, Lime Rock, Smithfield, South Smithfield, Moshassuck, Quinsnicket, and Louisquisset. It was eventually decided that the new town would be called Lincoln to honor the memory of the popular and recently slain president.

The new Town of Lincoln was incorporated on March 8, 1871, by an act of the General Assembly of the State of Rhode Island. Lincoln retained a town council form of government, some cash, and part of Smithfield's old debt. Within its borders were nine village-districts: Manville, Albion, Lime Rock, Quinnville, Lonsdale, Saylesville, Fairlawn, Central Falls, and Valley Falls. Central Falls and its portion of Valley Falls remained a village of Lincoln until 1895.

Despite the passage of so much time as members of a single, larger municipality, Lincoln's unique collection of village-districts have managed to extend their individual historical, social, and cultural identities into the 21st century.

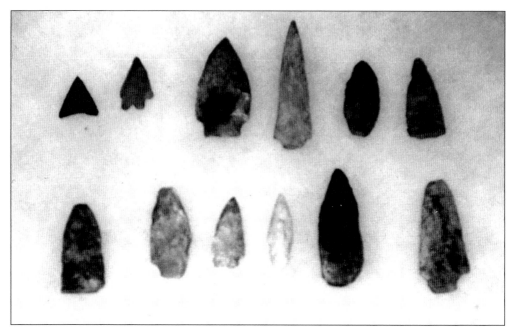

These arrowheads and spearpoints are physical reminders of the earliest days of Lincoln's history. In 1934, Arthur Cooper began finding the artifacts while plowing his homestead property off of Cobble Hill Road in Saylesville. It is common knowledge that bands of American Indians frequented this area, especially in the winter. King is said to have wintered annually within present-day Lincoln Woods. Tradition holds that he preferred to seek shelter inland and away from the ocean as the weather grew colder.

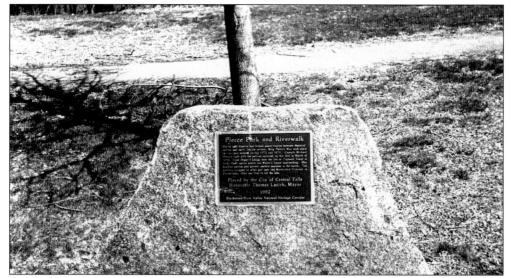

This monument in Pierce's Park on High Street in Central Falls commemorates Pierce's Fight, the bloodiest battle of King's War. Early in March 1676, Capt. Michael Pierce left Rumford with approximately 63 men and a number of friendly natives to investigate the reports that hostile natives were gathering around what is now Lonsdale. After a short journey north, Pierce's men surprised and defeated a small group of hostile natives. Pierce and his party returned the next day and were ambushed and massacred at this site. There were few survivors.

For 140 years, the villages that became Lincoln were subject to the laws, ordinances, and government of the Town of Smithfield. This is a copy of Smithfield's early ordinances. Edicts passed by the council suppressed vagrancy, prohibited the opening of places of trade and entertainment on Sundays or late at night, prohibited driving over a bridge faster than a person could walk, regulated the storage of gunpowder, and instituted an ordinance against bathing in public.

ORDINANCES

PASSED BY THE

TOWN COUNCIL

OF THE

TOWN OF SMITHFIELD,

JANUARY, 1866.

PAWTUCKET:
R. SHERMAN & CO., PRINTERS.
1866.

The first town meeting of old Smithfield was held at the home of Capt. Valentine Whitman Jr. on Great Road in Lime Rock. Within the walls of this 17th-century stone-end home, the founding fathers of Smithfield passed their first ordinances and decrees, establishing a town council form of government, a system of taxation, and penalties for civil disobedience.

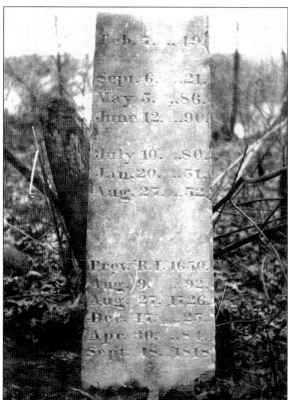

Samuel and Plain Wilkinson were the first settlers in the Manville area. The descendants of this pioneer couple founded Unity Furnace at Mussey Brook, near the Blackstone River. There, Israel Wilkinson and his sons operated a forge to produce the colony's first cut nails and screws. They also produced cannons for the Revolution. This limestone obelisk marker, located off of Central Street, documents the family's births, marriages, and deaths. The dates range from the 1600s to the 1800s.

This Colonial homestead and former farm once belonged to the notorious Deborah Hill, a spinster and sometime schoolteacher. Tales of her erratic behavior, including the severe physical and psychological abuse of the Ray children (who had been placed in her care), were exposed in the 19th-century book *Three Holes in the Chimney*, also known as *A Scattered Family*. The book was authored under a pen name of Didma, and was written by Ann Ray in her adulthood.

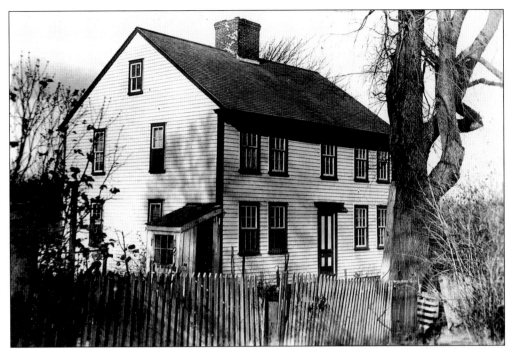

Many of Lincoln's Colonial-era homes have survived the passing of time. Though some have succumbed over the years, those that still stand are remarkable examples of the workmanship and ingenuity of Smithfield's first settlers. The home pictured in this 1903 photograph is the c. 1740 Israel Arnold House on Great Road.

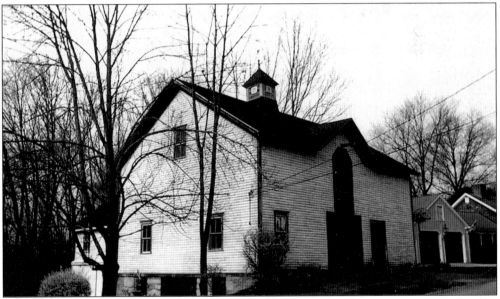

This late-19th-century building on Great Road is one of the best surviving examples of a combination carriage house and barn in the town of Lincoln. It is located across the street and slightly north of the Mount Moriah Lodge. A number of these buildings were built in all of the town's villages. Most of those that have not been torn down over the years have been converted into homes or adapted for use as modern garages to house automobiles.

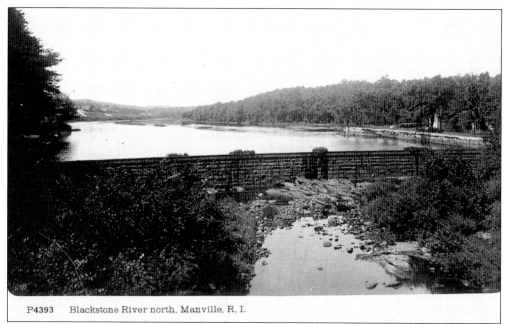

P4393 Blackstone River north, Manville, R. I.

This 1920s photo-postcard of the Blackstone River gives the viewer a glimpse of the architecture and huge granite blocks used to create a 19th-century milldam. Though no longer used to harness the river for waterpower, these old stone dams are a marvel to behold and produce beautiful man-made waterfalls. This very rare scene was photographed during an extended period of drought.

The arrival of the railroad in the 1840s predated Lincoln's founding. The early locomotives were powered by the steam produced from burning wood or coal. The railroad provided passenger and freight transportation opportunities that the inventors of the Blackstone Canal never could have imagined. The trains were inexpensive, fast, and even more important, dependable.

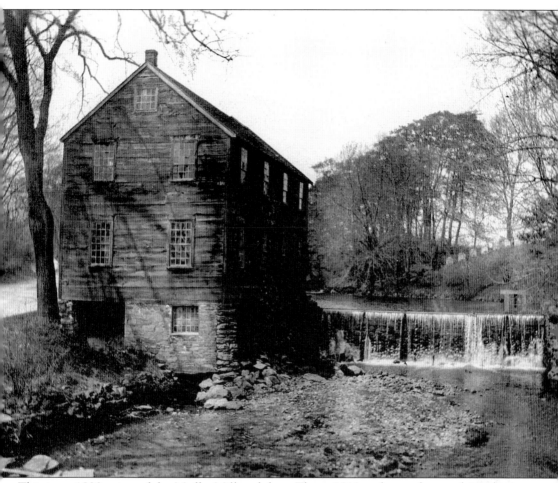

This is an 1890s view of the Moffet Mill and dam. The *c.* 1812 early wooden machine shop at times has been attributed to George Olney, but as far as anyone can remember it has been associated with the Moffet family. The mill straddles the very banks of the Moshassuck River at the edge of Great Road. During the 19th century, the building served as a braid mill, produced shoelaces during the Civil War, and served as a blacksmith and carriage shop afterward. Arnold's Bakery wagons were among those repaired and serviced here. The Moffets were accomplished machinists and blacksmiths. Even before the Town of Lincoln was created, industrial-minded families such as the Moffets had begun to cross the threshold of modern manufacturing.

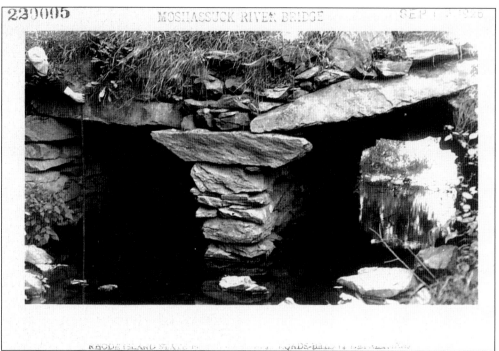

This crude but functional "stone slab bridge" on Great Road carried wagon and pedestrian traffic over the Moshassuck River from the 17th century to the 1920s. At one time these primitive bridges were in place all over the state. In the 1920s, the Rhode Island Department of Transportation identified these bridges and slated them for replacement. Though they were fine for wagons, the bridges never would have supported the stress of modern traffic. (RIDOT.)

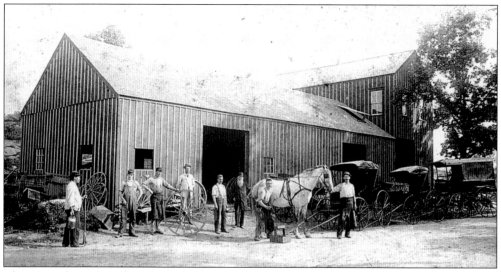

This view of James Anderson's blacksmith shop and adjoining carriage shop was taken c. 1890. From the time of colonization until the early 20th century, the art of blacksmithing could be found in almost every good-sized village. This blacksmith operation was located diagonally across from the present-day St. Jude's Church on the south corner of River Road and Front Street. Blacksmith shops faded into obscurity with the arrival of modern transportation.

In this photograph from the early 1900s, an unidentified child sits nervously on a baggage cart at the Albion train station, waiting to start a whole new life in Lincoln, Rhode Island. A trickle of French Canadian immigrants turned into a deluge as the prospect for mill employment drew people from Quebec Province, Canada. With high hopes for a better life, they found their way to the Blackstone Valley. The mass influx of French Canadian operatives shifted the cultural and religious makeup of mill villages in Lincoln and other neighboring communities.

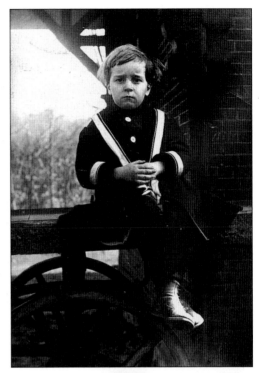

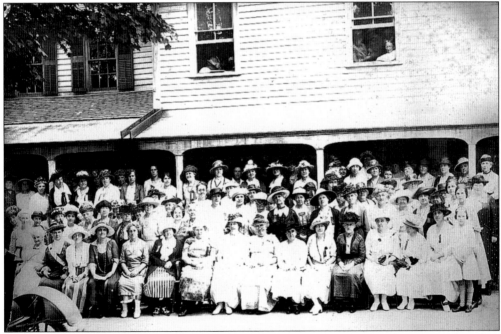

Members of the Lime Rock Women's Guild donned fine dresses and very large hats when they gathered for a meeting on a sultry summer day in the 1920s. This picture was taken in front of the Lime Rock Grange headquarters, the c. 1807 North Gate Toll House on Old Louisquisset Pike. The guild was a separate organization and not Grange related. The women did, however, use the building for their meetings.

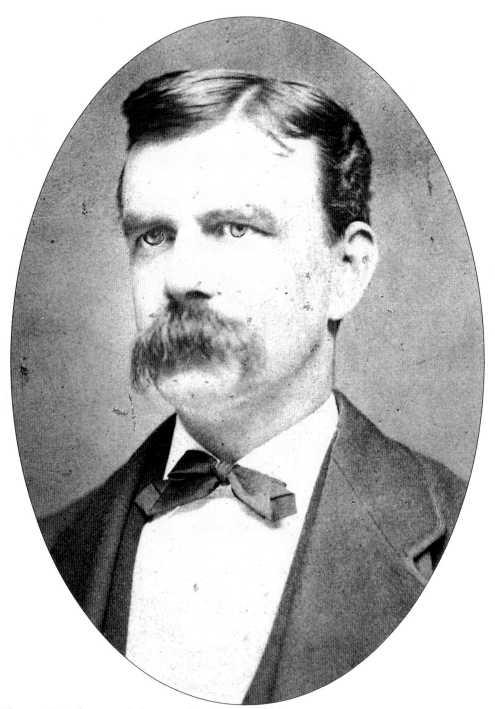

This *c.* 1880 cabinet-card photograph is a portrait of decorated Civil War hero and Lime Rock native William S. Perrin as he appeared near the end of his life. A brevet captain at the time of his discharge, he had commanded Battery, 1st Regiment RI Light Artillery at Gettysburg on July 3, 1863. Wounded twice and captured once, Perrin had suffered a great deal throughout the remainder of his life from the wounds received in the battle before Richmond.

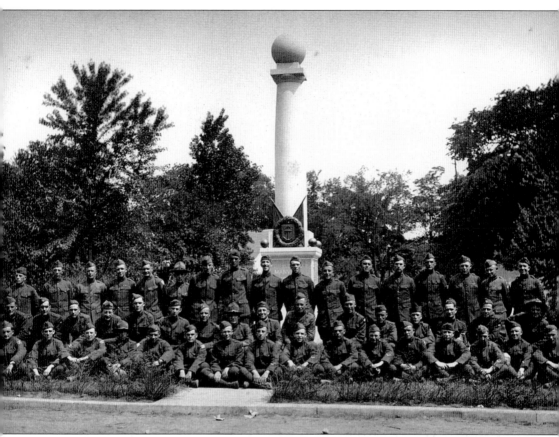

Manville's surviving World War I veterans gathered on November 11, 1919, to dedicate this country's first monument in recognition of those who served in the war. The memorial was designated that day as being "the first of its kind in the United States" by U.S. Sen. Henry F. Lippitt. Though the dedication took place on Veterans Day 1919, the monument was actually completed in 1918. Two hundred and twenty-eight names are inscribed on this, the most extraordinary veterans' monument in the town of Lincoln.

With the aid of the Wilkinsons from the Unity Furnace in Manville, Samuel Slater re-created the industrial textile machines of England in 1790s Pawtucket. His textile weaving looms and processes were adopted by other industrialists and gave birth to this country's Industrial Revolution. The mills and mill villages of Lincoln owe their very existence to Slater.

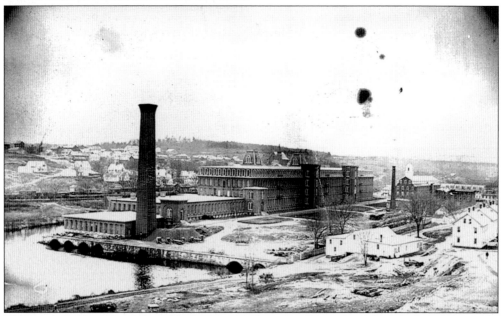

The gigantic Manville mill, millhouses, and village are depicted in this *c.* 1895 photograph. This large mill and others like it transformed the image of Lincoln from a farming community to a manufacturing town during the 19th century. Portions of this mill and its associated village were located on both sides of the Blackstone River. At that time, this view across the river from Cumberland was not obstructed by trees.

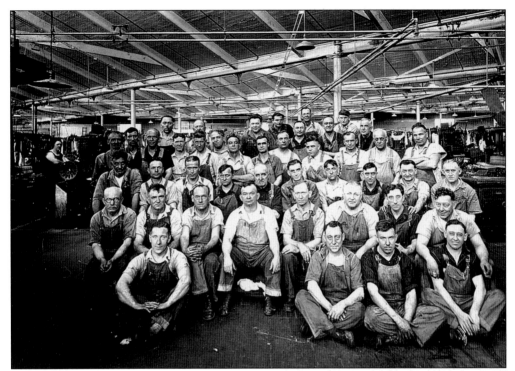

This group photograph of all of the loom fixers employed at the Manville mill was taken in the first half of the 20th century. It took all these men and their specialized tools and talents to keep the large cotton mill's countless looms in operation. Despite improvements in technology and design, the complex machinery required intense routine maintenance and frequent repair.

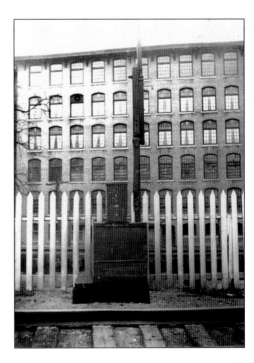

Textile mills appeared in all of Lincoln's villages along the banks of the Blackstone. The large Albion mill fills the background of this 1920s photograph of a railroad mail crane. The Albion mill employed hundreds of people, most of whom lived in the village itself. Textile manufacturing dominated the local economy of Lincoln for most of the 19th century.

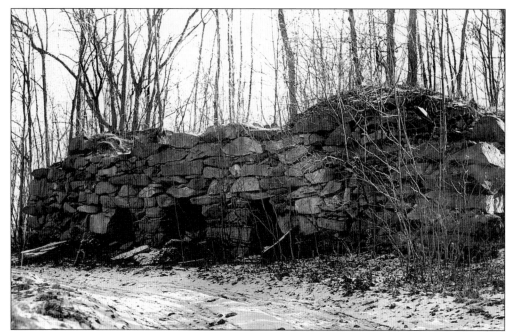

Unique among its peers, the economy of Lime Rock was not driven by the textile industry. This village was located away from the river, and focused on the quarrying and burning of raw limestone in huge kiln ovens. The production of quicklime was big business because the product was a necessary component of early plasters and mortar. This photograph depicts one of Lime Rock's very early and primitive lime kilns.

Quinnville was involved in the world of textiles and also took part in the lime industry. To the left of this view of an overgrown section of the canal in Quinnville are the remains of an old lime kiln and spoils pile. Located between Lower River Road and the canal, the site was leased by William Whipple to a group of partners in the 1700s. At least two kilns were built here. So began the Quinnville-Old Ashton association with Lime Rock. A small textile operation also existed at the northern end of the village.

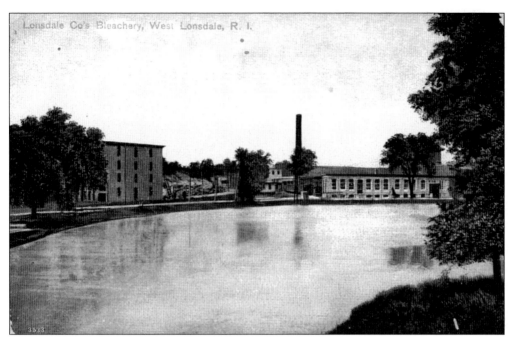

This early-20th-century printed postcard shows a view of the c. 1840s West Lonsdale Bleachery in Lincoln, as it appeared across the Blackstone River from East Lonsdale in the town of Cumberland. The two Lonsdales were established by the mill company, but were divided by the river and municipal boundaries. The two villages were distinguishable by the terms "Old Lonsdale," which meant Lonsdale (Lincoln), and "New Lonsdale" (Cumberland).

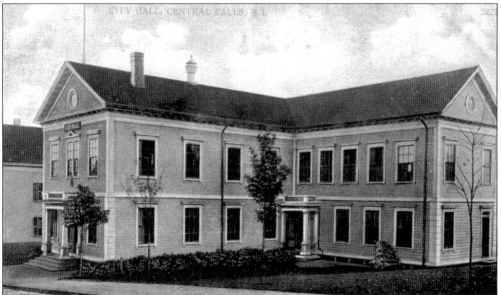

This is a view of the first Central Falls city hall. When the Town of Lincoln was created from Smithfield, it took residents two years to raise funds for a town hall. Lincoln finally opened its first town hall on Summit Street in the village of Central Falls in 1873. When the village became an independent city in 1895, Lincoln once again was without a town hall. Central Falls took over the building and used it as its city hall until 1928.

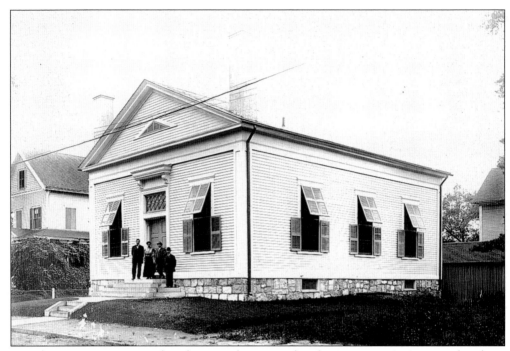

Lincoln town government found a new home in this former *c.* 1840s Baptist church in Lonsdale. Initially the home of one of Lonsdale's oldest churches, on Lonsdale Avenue and Main Street, the Greek Revival building was lifted off of its foundation and moved south along a short stretch of Lonsdale Avenue. This former church was used as the town hall and Lincoln Police Department until a new, modern town hall was opened in 1963.

"FREEDOM FROM DEBT" CELEBRATION

TOWN OF LINCOLN

RHODE ISLAND

Lonsdale Hall, Lonsdale, Rhode Island

Sunday, July 11, 1943

The people of the town of Lincoln did have some good news during World War II. On Sunday, July 11, 1943, the townspeople gathered at Lonsdale Hall and celebrated Lincoln's freedom from debt. The celebration culminated with a public burning of the bonds. Presiding over this unique ceremony was Albert J. Bucklin, town treasurer.

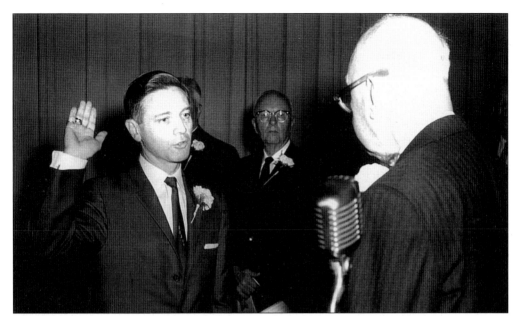

On July 1, 1961, Frank A. Carter Jr. (left) took the oath of office as Lincoln's new town administrator. He was the second man to hold that office and the town's first Republican administrator. Associate Justice G. Frederic Frost of the Rhode Island Supreme Court administered the oath of office. Carter had spearheaded the successful effort to change Lincoln town government from a town council form to a chief executive and town council format. (Frank A. Carter Jr. Historical Research Library.)

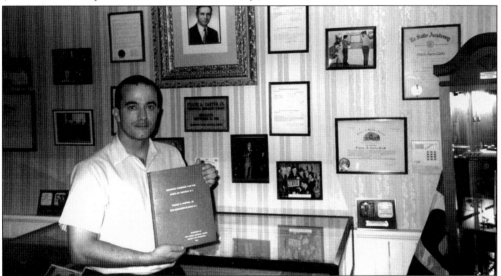

Normand P. Dauphinais, property chairman of the Blackstone Valley Historical Society, displays an original copy of the Lincoln town charter that changed the town's local government in 1958. The document was donated to the society for preservation by Louise Carter. From 1871 to 1958, the town had operated under a governing system adopted from old Smithfield. This innovative town administration concept was created by Frank Carter and the Lincoln Charter Commission. It has since been adopted by many other towns in nearby and distant states.

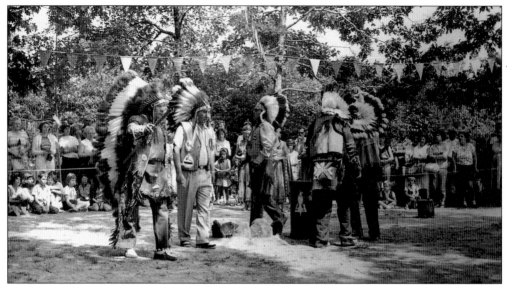

In 1962, American Indians returned to Lincoln. This time, however, it was to hold a peaceful powwow at "the place of meeting," now Louisquisset Pike. Throughout the day they performed traditional dances and explained the meaning of common native customs and culture to the delight of the Lincoln residents who came out to attend the historic event.

In 1971, the town of Lincoln held a centennial dance and countless other entertaining and serious programs to commemorate the town's 100th birthday. Among the more entertaining spectacles was this dance at the Manville Community Center. Appearing in this photograph are, from left to right, Rene Fortier, Claire Fortier, Walter Comire, Nancy Comire, Walter Sowiecki, Judy Sowiecki, and Claudette Paine, Lincoln's longest-serving finance director.

Two

MANVILLE

Once known as Sennetchonet by the American Indians and Sennetchonet Island by the early colonists, the area now known as the village of Manville began its existence as a wading place. Wading places were important locations along the Blackstone River where shallows and slower currents allowed people to cross by foot, horse, or wagon.

Among the first to settle here were Samuel and Plain Wilkinson, who arrived and established a homestead near Sayles Hill in the 1670s. The Wilkinsons' descendants ignored an English parliamentary decree and established a forge at Mussey Brook. The forge, called Unity Furnace, produced the first American-made cut nails and screws. The forge also assisted the Revolutionary effort by producing cannon and cannon balls.

By 1811, most of the Wilkinsons had joined Samuel Slater in Pawtucket. A partnership consisting of Thomas Mann, Samuel Hill, William Aldrich, and others purchased the Wilkinsons' property along the Blackstone River. A wooden cotton mill was built, and the manufacturing operation was named Unity Manufacturing Company.

Another prominent member of the Mann family was Samuel Man (who preferred to use only one "n" in his last name). Samuel was a larger-than-life individual and the man after whom the village is named. Samuel Man and business partner, William Jenkins, acquired Unity Manufacturing in 1821 and renamed it Jenkins and Man. The two men continued to purchase land adjacent to the wooden mill until 1826, when they laid out a foundation for a giant textile mill.

Jenkins and Man built housing, constructed the first public school, a library, and mill stores in the village. The company also assisted in the establishment of the village churches, and provided other social and recreational amenities for their mill operatives.

The Great Depression and the unionization of workers in the 20th century placed a heavy financial burden on successive owners of the mill company and the textile industry as a whole. Production and profit at the mill slowly declined. In 1955, a devastating flood and ensuing fire turned the Manville mill into a mountain of smoldering rubble. The mill village was intact, but deprived of its largest mill and employer.

The man and the mill that gave Manville its name may no longer exist, but the community and several historic buildings have survived. Today, the village of Manville is primarily residential and has some light commercial and manufacturing activity. The village is predominantly populated with French Canadian descendants of the original mill operatives who came to work in the Blackstone Valley during the heyday of textile manufacturing.

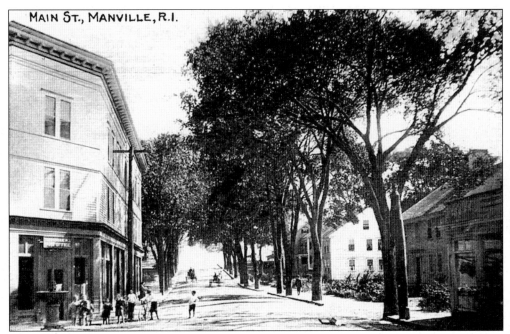

A wonderful early-20th-century view up Manville's Main Street is depicted in this image. Samuel Man was directly responsible for preserving this peaceful view into the next century. The railroad wanted rails in the area at the foreground of this photograph. Samuel discouraged the railroad from laying tracks across what he considered to be his Main Street by holding a rifle and threatening to shoot the first rail worker to stick a shovel in the ground. The railroad backed down and placed the rails near the river.

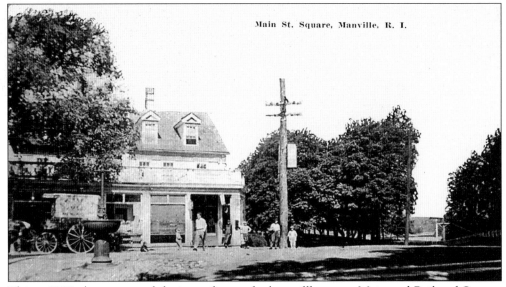

Main St. Square, Manville, R. I.

This c. 1900 photo-postcard depicts a former duplex millhouse at Main and Railroad Streets. The corner used to be referred to as Main Street Square. The building was one on the village's first millhouses. Though greatly modified, it still stands at the corner of Main and Railroad Streets, and now is the home of the Harmony Cafe. In front of the wagon, to the left of the scene, is a famous Jenks Watering Fountain.

26

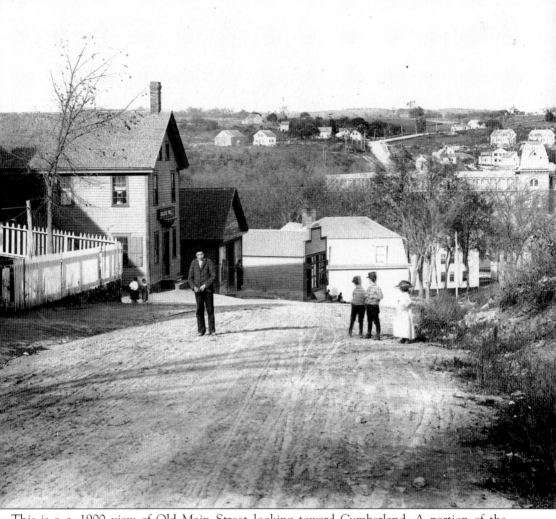

This is a c. 1900 view of Old Main Street looking toward Cumberland. A portion of the gargantuan Manville Mill can be seen on the right. The children in the foreground are unidentified, but are possibly members of the Handy family. By this time, the village had grown considerably, and buildings had sprung up along almost the full length of both Main Streets.

This rare image shows Central Street, looking north toward the Music Hall. It was taken at 4:00 p.m. on August 4, 1910. Unsurprisingly, village roads were still dirt, and permanent sidewalks had yet to be installed. The small cottage second on the right was the home of village school mistress Mary-Anne (Jackson) Swindell. All of the homes and buildings that are familiar today had already been constructed by this time.

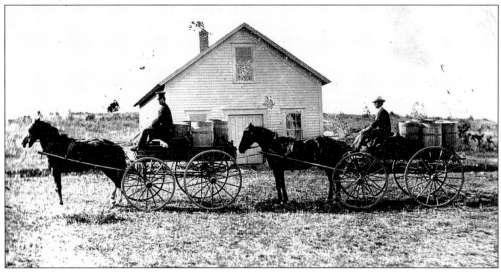

Appearing in this tintype photograph from the 1880s are two horse-drawn wagons from Girourd's general store. The family obtained perishable goods, such as milk, eggs, produce, and other items, from farms on the outskirts of Manville. The store owners then marketed the goods to the working populace of the village center. Many families had no individual transportation, and the general store was a very convenient way to get goods.

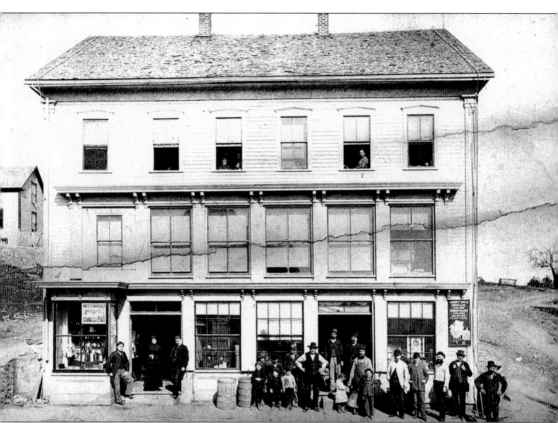

This is a wonderful image of the Girourd and Company general store as it appeared on Winter Street *c.* 1900. The Girourds were one of the most respected and well-known families of Manville. Their store carried every conceivable item a person could use or need in a small village. The family operated this store during the 19th and early 20th centuries. Adelina Girourd, the proprietress, can be seen standing in the center of the left doorway.

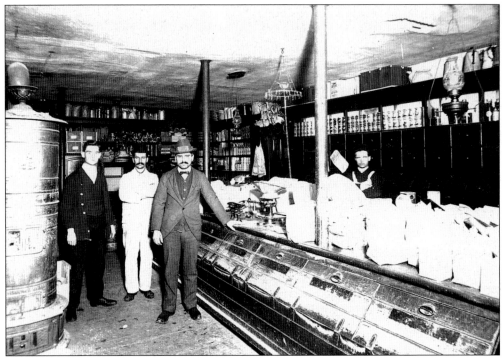

Shown in this early-1900s photograph is just one interior portion of the first floor of the Girourd and Company general store on Winter Street. Foodstuffs were sold on the first floor. Other sections of the store featured clothing, hardware, and many other products that were indispensable to the residents of Manville village. Virtually all of the adult members of the Girourd family were involved with the business in one way or another.

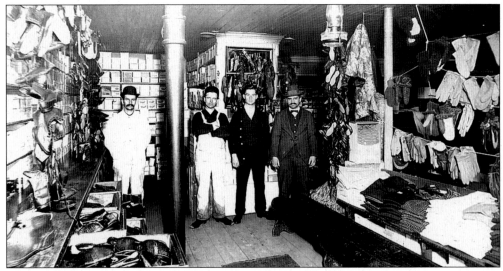

Members of the Girourd family were always on hand to serve potential customers. The second floor of the store was the subject of this photograph. Shirts, pants, gloves, and shoes were among the items on display for sale. The store carried a large selection and kept a heavy inventory. The store was so popular that, very early on, the street alongside the business was officially named Girourd Street by the town.

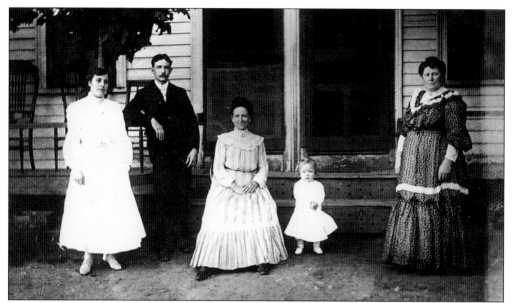

This early-20th-century group photograph of the Gladu family was taken at their Flat Street residence in Manville, Cumberland. Manville's mill and a portion of the mill village extended across the Blackstone River. Pictured are, from left to right, Mary Jane Lepine, Joseph Gladu, Valeon (Lepine) Gladu (Joseph's wife), young Alfred Gladu (child of Joseph and Valeon), and Marie Lepine. As an adult, Alfred Gladu became Manville's fire chief, and operated Grennon's Market on Park Street in the village. Alfred's son, Roger Gladu, chose civil service, working at the Manville post office and serving as a captain of the Manville Fire Department. He is also an undisputed expert on Manville history.

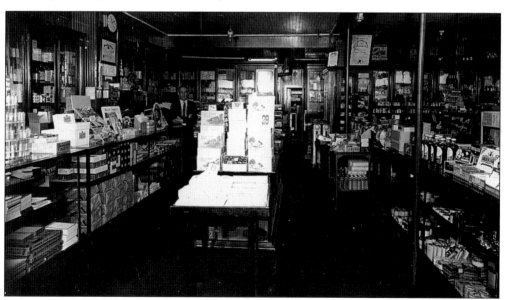

Beatrice Durand snapped this photograph of pharmacist Albert Zurlinden at his counter in the 1930s. He owned and operated Zurlinden's Pharmacy out of a storefront located at what was then 50 Spring Street. The store was extremely popular with residents, and supplied all kinds of useful prescriptions, remedies, fine cigars, cards, candy, and more.

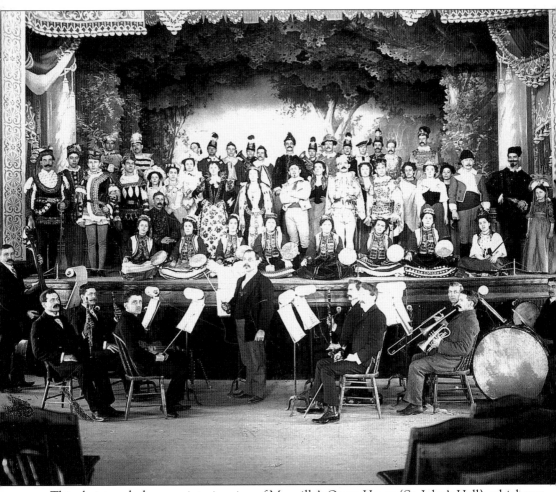

This photograph shows an interior view of Manville's Opera House (St. John's Hall), which was located on Bouvier Avenue. The cast of the Manville Drama Club (on stage) and an ensemble of the Manville Brass Band (seated in front of stage) are shown as they appeared in 1895. Manville Brass Band leader Ephrem B. Mandeville (standing front center) produced and directed many lavish operettas and musicals at the old opera house.

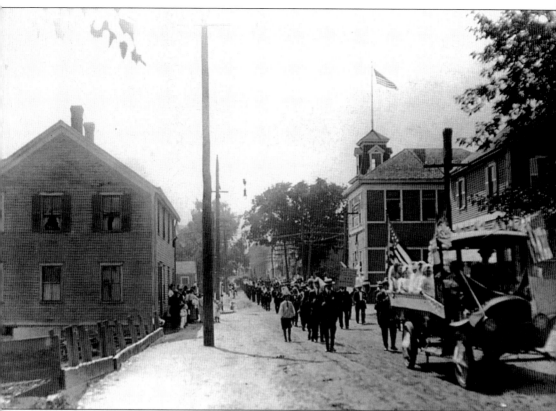

The building at the right rear of this c. 1908 parade photograph is the Manville Music Hall on Central Street. The Victorian Tower House Hall was built in 1895 by Ephrem B. Mandeville and the Manville Brass Band. It served as the group's headquarters until the band dissolved in the 1950s. The hall was the site of many parties and receptions, as well as for practice by the band. The first floor also served as the Manville police station, complete with jail cells. The structure is now a Blackstone Valley Historical Society museum building, which houses artifacts relating to town and village history.

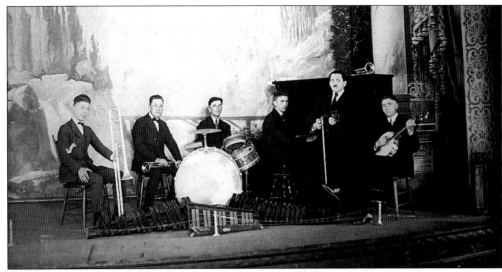

Ulysses Lariviere (standing) and his orchestra are shown here as they appeared onstage c. 1900. This photograph was taken at the old Opera House on Bouvier Avenue. Unlike the large brass bands, this smaller group was more adapted to play weddings, social engagements, and receptions in the local villages and Woonsocket. Among the instruments Ulysses played was an unusual string violin with a horn amplifier. It is one of the instruments on display at the Manville Music Hall.

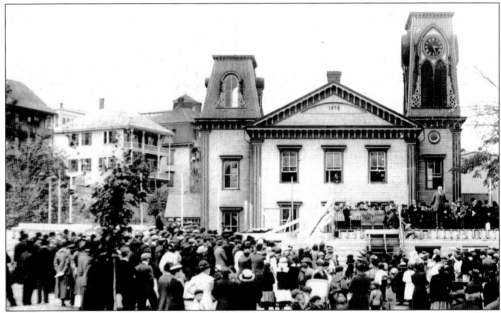

Graduation Day is shown here at the original Manville Public School c. 1900. This first school was built by Jenkins and Man in 1876. While St. James School provided parochial French-English schooling, the mill company and the town provided the non-Catholic children of Manville village an opportunity for a formal education also. While many mill owners were portrayed as stern and uncaring, Samuel Man and his successors built a school and a library. Samuel may have been a very shrewd businessman, but in no way was he miserly toward the residents of his mill village. (Beatrice Durand.)

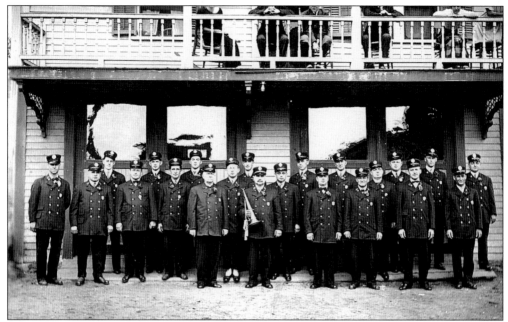

This early-19th-century photograph of Fire Chief Seraphin Fortier and the Manville firefighters was taken in front of the original fire station. The bullhorn Chief Fortier is holding at the center of the photograph is preserved on display at the Manville Music Hall. The horn was donated to the Blackstone Valley Historical Society for preservation by Claire Fortier. This first village fire station was located on Central Street. The hilltop site gave firefighters a great view of the village.

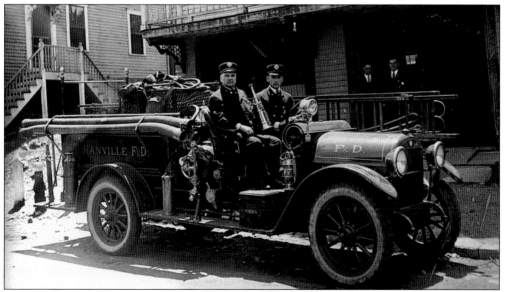

Manville Fire Chief Seraphin Fortier (left) and his son Henri Fortier were photographed in 1923 aboard the village's first fire truck. The two gentlemen looking on from behind were Manville fire officials. This image also was taken in front of the original fire station. The truck's electric bell, seen behind the chief, was acquired and preserved by Rene Fortier. It is on display at the Music Hall.

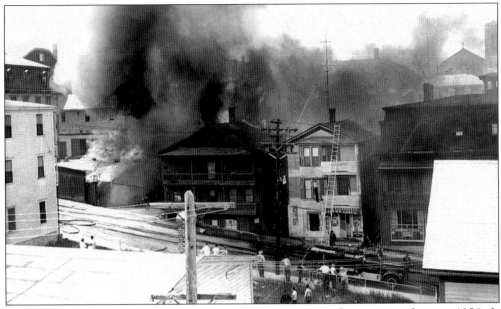

This photograph of a Manville tenement fire on Summer Street was taken in 1956. It demonstrates the sheer enormity of the task and danger Manville firefighters face any time fire breaks out in the village center. For over a century, the Manville Fire Department has protected the lives and property of village residents. Formed in the summer of 1891, it has always been an all-volunteer department.

This is a 19th-century wallet-sized portrait photograph of Carlisle Vose. In addition to Carlisle, the Vose family produced a number of prominent and outstanding citizens of Manville, including Walter Vose, fire district treasurer. Carlisle was one of the driving forces who helped Manville establish its fire department. He stayed closely involved with the department after it was founded, and he served as the district fire tax assessor for almost a decade.

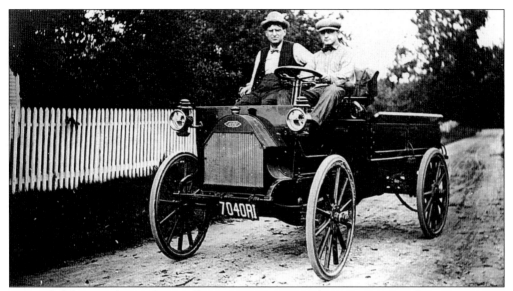

Some wealthier residents of Manville were using motorized transportation a few years prior to the fire department. Joseph Girourd bought his deep-red horseless carriage-truck in 1912. He was among the first, if not the first village resident to make the switch from horse-driven vehicles. However, it is not apparent whether he did any of his own driving. Joseph, the owner, is the passenger on the left. The driver on the right is unidentified.

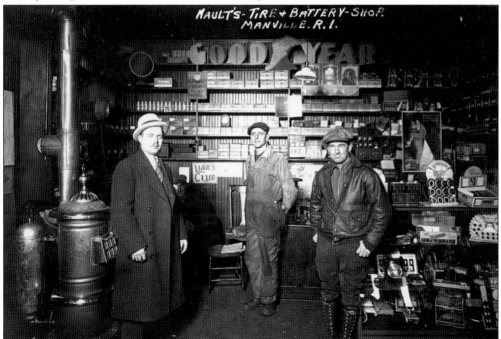

The arrival of motorized vehicles in Manville prompted talented mechanics to open service and filling stations. One of the first to get into this groundbreaking enterprise was Pete Nault. Pete and his family operated the Railroad Street service station for decades. Shown in this interior photograph of Nault's Tire and Battery Shop are, from left to right, Leo Pare, Rene Rouleau, and Pete Nault. Seated in the rear of the shop is a member of the Lafontaine family.

The Enrico Caruso Social Club headquarters was constructed on Bouvier Avenue in the 1920s. The civic organization was formed by Manville's Italian American community. The club's original purpose was to provide members with a social safety net of benefits not yet provided by the state. The organization and its headquarters continue to support and house one of the village's most active social clubs.

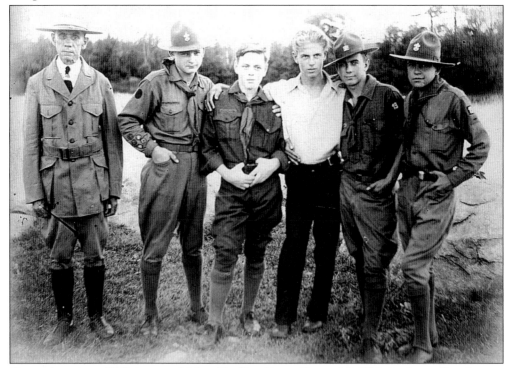

Shown here is a 1928 image of Manville Boy Scout Troop 19. This is the earliest-known photograph of a Lincoln Boy Scout troop. Though only a few in number when they started out, Manville's Boy Scouts have kept up and expanded this long-standing and proud tradition within the town. Pictured are, from left to right, Fred Gower, Scout leader, with Scouts Joseph Kusdiba, Francis Laffan, Jackie Bland, Harold Bisonette, and Emile Blaine.

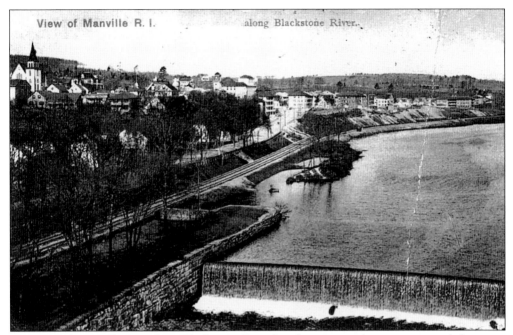

A "View of Manville R.I. along Blackstone River" is the caption that accompanied the scene on this illustrated postcard produced in 1909. Many of these cards were bought and sent by Manville residents to relatives in Canada. The people of Manville were truly proud of their adopted village. Though it was originally industry driven, the community was, and remains, an attractive place to reside.

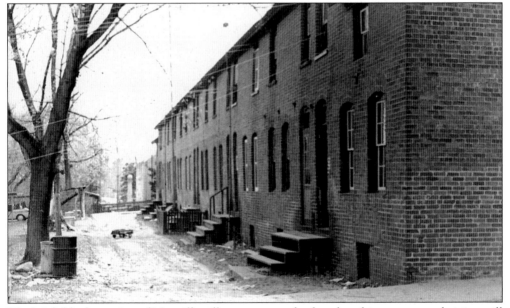

The brick-blocks section of Manville village attests to the fact that this was once a thriving mill town. Several long rows of these c. 1890 brick millhouses were built by the mill company to house the multitudes of operatives needed to run the mill. The mill no longer had the luxury of building single-home and duplex housing for hundreds of new workers.

First-floor commercial storefronts were everywhere in the bustling village of early-20th-century Manville. Spring Street alone had two pharmacies. The shops were popular with children because they sold penny candy also. The Spring Street storefront in the background of this photograph from the mid-1920s was Houtman's Pharmacy. Standing in the doorway are, from left to right, Jeanette (Savoie) Biagetti, J. Paquin, Eugenie Leduc, and Romeo Savoie.

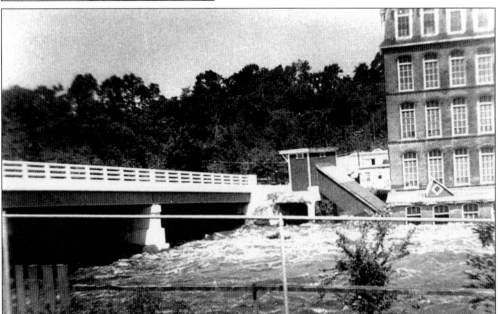

The textile industry in Lincoln and other surrounding communities suffered a number of major setbacks in the 20th century. The Depression, labor unrest, and the relocation of manufacturing to the southern United States were major factors. Major flooding also physically damaged many of the mills along the river. In this 1955 photograph, the floodwaters associated with Hurricane Diane are barely passing below the brand-new Manville Bridge. To the right of the bridge, a portion of the mill itself can be seen falling into the river.

The domination of Manville's economy by manufacturing interests came to a final and fiery end on the afternoon of September 12, 1955. This photograph was taken when the fire that destroyed the mill was well under way. Fire departments from all over the state came to assist, but the mill was hopelessly engulfed. Firefighters concentrated their efforts on protecting the village and its homes from the fire's blowing embers. The mill buildings burned out of control for more than a day, and continued to smolder for weeks. The Manville mill was gone forever.

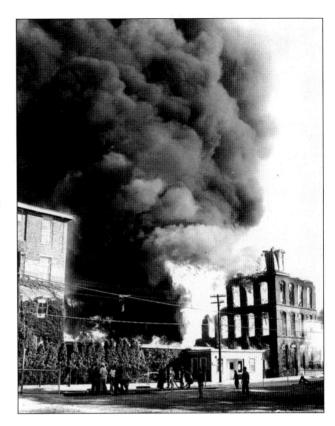

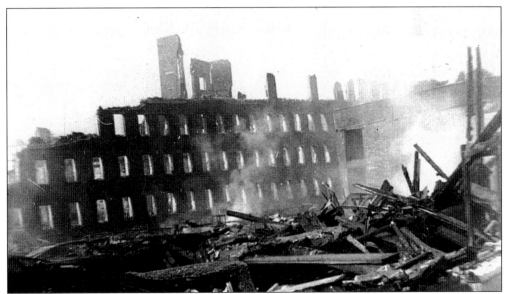

A daring photographer produced this image in the aftermath of the Manville-Jenckes fire. The photograph was taken while the rubble was still smoldering. The devastating fire was attributed to an employee's torch. Workers were attempting to repair a flood-damaged portion of the mill when the fire broke out.

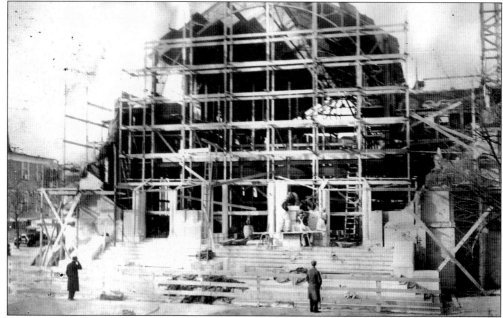

St. James Roman Catholic Church has proved itself to be the most successful church in Manville's history. The original c. 1873 wooden church was lost in a 1919 fire. After many years the members of the French-speaking parish finally raised the funds to build a new brick church. This early-1930s photograph shows the supports and scaffolding in place during the construction of the new St. James Church's .

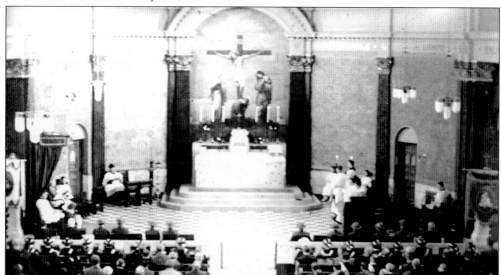

A view of the lavish, Romanesque interior architecture of the new St. James Catholic Church can be seen in this 1935 photo-postcard image. The new church was built in the same exact spot as its predecessor. Parishioners marveled at the beauty of the new structure's imported marbles, enormous paintings, and artistic stained glass. When construction of their new parish was completed, Manville's Catholics finally were able to erase the terrible memories of the 1919 fire. Except for a few 20th-century modifications, the church appears much the same today as it does in this photograph.

The Sisters of St. Anne took a moment out of their busy day to assemble for this group photograph, taken by Beatrice Durand in the 1920s. The French- and English-speaking nuns provided the only bilingual school, and offered a parochial alternative to public education in Manville. Under the church's supervision, they operated and taught most of the village's Catholic youth at St. James School from 1876 until the early 1970s.

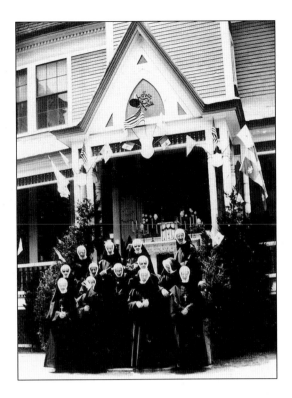

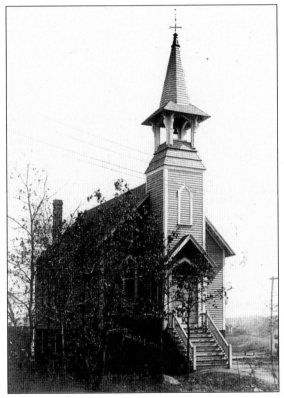

This photo-postcard shows Manville's Primitive Methodist Church on Main Street c. 1900. When it was first constructed, the church had an enormous Wicks organ. The organ was purchased by a Cumberland Primitive Methodist church in 1946. The small congregation in Manville finally sold the church in the early 1960s. This attractive late-Victorian wooden church burned to the ground on February 16, 2001, in a tragic fire that claimed the life of George Rowey, a well-known and popular village resident.

This is the second Manville Public School as it appeared c. 1949. The first village public school appears on the front cover of this book. When the original school burned down in 1910, the village quickly produced this more fire-resistant, brick replacement. This school closed when the new and modern Northern Lincoln Elementary School was built between Manville and Albion. This former public school off Manville's Main Street is now an apartment house.

Future town administrator and teacher Frank A. Carter Jr. (center) was an instructor at the Manville Public School. On the left is Raymond Descoteau, and on the right is Theodore Bishop. Carter would eventually leave education for a career in local elected office, state government, and public and private law. The Frank A. Carter Jr. Historical Research Library, housed at the Manville Music Hall, was posthumously dedicated in his honor in 1999.

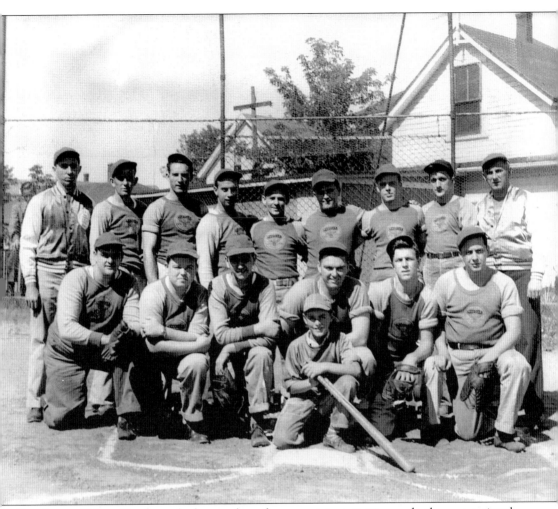

Residents of Manville always had a number of sports, civic activities, and other recreational outlets to choose from. Village businesses and individuals often sponsored the youth and adult sports teams. Shown in this Manville Garelick baseball team photograph from the early 1950s are, from left to right, the following: (first row) Maurice Delisle, Fernand Latour, Marcel Latour, Bob Bently, Napoleon "Nap" Lajoie, and an unidentified mascot (at front center); (second row) Henrio Berard, Olrich Paquin, Lucien "Lou" Desjardins, M. Pontbriand, Arthur Tusingnant, Constant "Cy" Laprade, J. Heroux, and R. Dufresne.

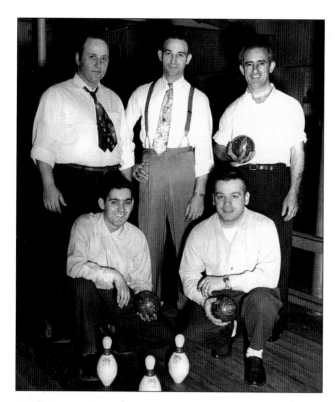

Bowling was also a favorite village pastime of young and old alike in the 1940s and 1950s. Individuals and teams could literally walk to the lanes on Winter Street. Pictured in this photograph are, from left to right, the following: (kneeling) Robert "Bob" Chenail, and Jules Ross; (standing) Noel Peletier, Lucien "Lou" Desjardins, and unidentified.

The sport of quoit throwing took Manville by storm in the 1960s and early 1970s. Similar to horseshoes, but distinctly a French Canadian favorite, quoits are very heavy bronze rings thrown toward an iron pin on a sandy court. Lou's Cafe hosted the sport in Manville. It became so popular that Lucien "Lou" Desjardins built a sizable indoor court for serious year-round league competition. The game is still played in Woonsocket today.

Jeanette (Boisvert) Lariviere sits atop the foundation of what was to become the new Manville Pharmacy and present-day One-Stop Liquor Store on Railroad Street. Jeanette and other longtime residents have helped preserve the historic French Canadian culture, customs, and charm that have made Lincoln's northern villages unique. Many children of the 20th century were exposed to French Canadian customs and language through their parents. Many still understand French, even if they do not speak it fluently. It is not the least bit unusual to hear French spoken in Manville or Albion today.

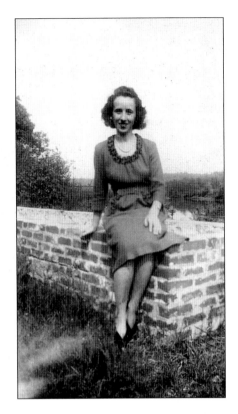

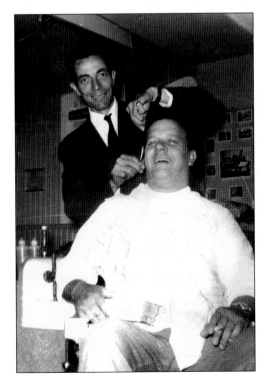

U.S. Sen. Claiborne Pell sits Manville's barber down for a trim in 1960. Manville was truly blessed by the presence of interesting and colorful 20th-century residents. At 17, Ludgar Lacroix emigrated from Quebec to Woonsocket, and then to Manville, his permanent home. He operated his village barber shop for more than 30 years. Lacroix was politically active, studied hypnotism, and became a celebrity, entertaining thousands of people at public demonstrations during his lifetime. He also experimented with alternative energy and hybrid-power vehicles.

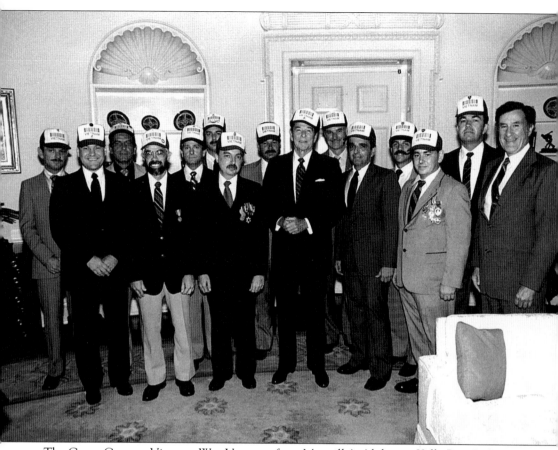

The Green Cappers-Vietnam War Veterans from Manville's Alphonse-Yelle Post 9, American Legion, made history when they were welcomed to the White House Oval Office to meet with President Reagan in 1985. Shown in this photograph are, from left to right, the following: (first row) Donald Gendron, Roger Caron, Robert Leclerc, Pres. Ronald Reagan, Bruno Kurowski, Robert Lapearl, and U.S. Sen. John Chafee; (second row) Maurice Goulet, Raymond Lussier, Bernard Desjardins, Roland Laforest, Ted Mochnacki, Rene Fortier, Thomas Manigan, and Robert Seaton. (Claire Fortier.)

Three

ALBION

American Indians referred to the central and north-central portions of Lincoln as *Loqucesit* or *Loquasqussuck*. The English found themselves pronouncing it Louisquisset, a name more familiar with people today. The word's meaning is loosely translated to describe a place of meeting. The English, who were not entirely fond of native references, assigned the name Monticello to the farming settlement south of Manville; this was done in part as an association with the chalky white cliffs of an area in England.

Monticello had a significant agricultural settlement, but its location along the Blackstone River also made it attractive to early industrialists. Samuel Hill owned the Albion water privileges, and in 1830 sold them to a group of investors including Preserved Arnold and members of a branch of the Wilkinson and Harris families. The partnership had put up a small mill at the Albion site seven years earlier. With water privileges now in hand, the men proceeded to construct a second mill, and a third was added two years later.

By 1856, the name Albion had come to be associated with this mill operation and village. Now owned and controlled by the Chace brothers, Harry and Samuel, the new Albion Company joined in a venture with the Manville Company to construct a road (now known as New River Road) to facilitate transportation between the two villages. In 1858, the Albion Company also built the very familiar iron bridge that spans the Blackstone between the towns of Lincoln and Cumberland.

Subsequent generations of Albion residents continued to work at the mill as it underwent a number of ownership changes. The Berkshire Spinning Company and others used the mill until it closed its doors in the latter part of the 20th century.

The village of Albion contains some 18th- and many 19th-century buildings. Acres of former farmland are now part of an extensive golf course. The large tracts of manicured grassland and wide vistas have allowed the former mill village to retain a greener, more open-space appearance than its sister village to the north.

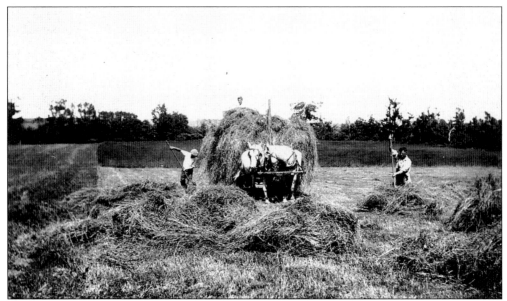

Agriculture dominated the outlying areas of Albion long before the era of textile manufacturing. Even at the height of the Industrial Revolution, there were several family farms and one mill farm in the village. Large quantities of hay had to be gathered and stored annually to feed livestock over very long New England winters. Proper drying before storage was extremely important. Damp or wet hay would become moldy and useless. Spontaneous combustion, though infrequent, could also spark a barn fire.

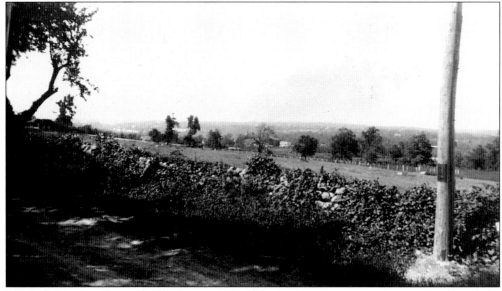

The lush green pastures of Kirkbrae Farm can be seen lying just beyond a stone wall and the unpaved Old River Road in this early-1900s photograph taken from the edge of Theinert Farm. The Samuel Clark homestead, also known as the Church Farm, was very highly regarded in the dairy business. This farm was one of the oldest in the area, having been established in 1790 by Samuel Clark. The Church family was renowned for their purebred Ayrshire milking cows and four-percent milk.

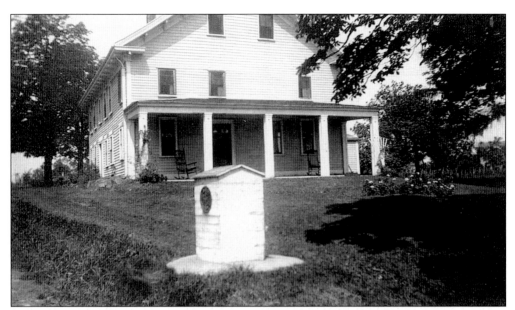

This photograph of Theinert Farmhouse was taken in the early 1900s. Part of the house likely dated from the original 18th-century homestead, and was also known as the John Carter Brown House. It was described by a member of the family as having seven bedrooms, a loft, large living and dining rooms, a study-sitting room, and a very large kitchen. In addition, the house had a safe room with a hidden entrance tucked away in a wood storage room off the kitchen. Unfortunately the farmhouse was torn down sometime in the 1950s.

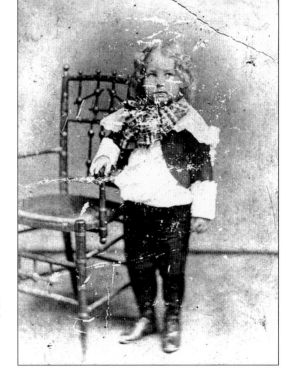

Walter Theinert was born in Providence in 1895, and moved to Albion with his parents and siblings in 1902. Walter was about five years of age when this photograph was taken. Despite the enormous amount of work associated with running a large farm, Walter's parents saw to it that their son received an education. He attended and graduated from the Albion grammar school in 1909.

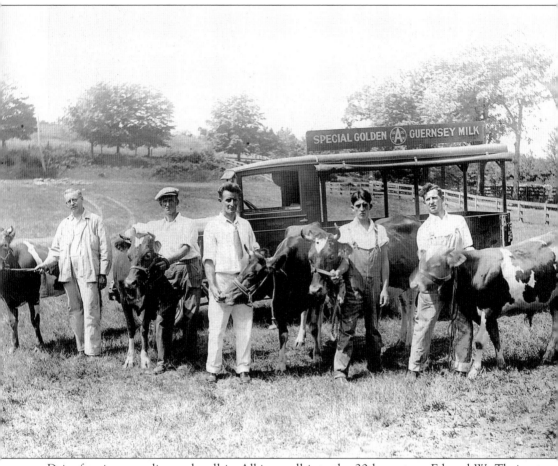

Dairy farming was alive and well in Albion well into the 20th century. Edward W. Theinert and his sons maintained a large herd of Guernsey cows. The milk produced at the farm was marketed as far away as Pawtucket. Farthest to the left in this vintage *c.* 1930 photograph is Al Riang (a cousin), and third from the left is William Theinert. Farthest to the right is Walter Theinert. The second and fourth men from the left are unidentified and may be hired farm hands. The vehicle behind the men is one of the farm's delivery trucks. This photograph may have been taken for promotional purposes. Many farms produced and distributed brochures extolling the health virtues of grade-A milk from tested cows.

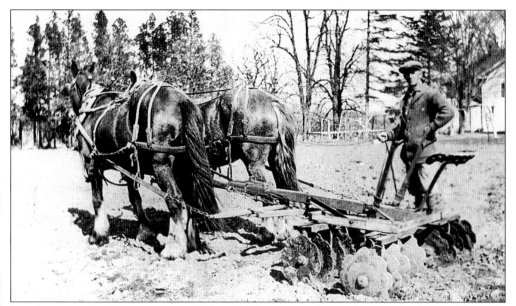

In a long-vanished farming scene, Walter F. Theinert is shown plowing the fields of the 350-acre farm in 1929 with the aid of two large workhorses. Walter sold his interest in the farm to his brother William in 1940. Between 1945 and 1947, the property was sold off in parcels, and most of it has since been developed into suburban residential neighborhoods.

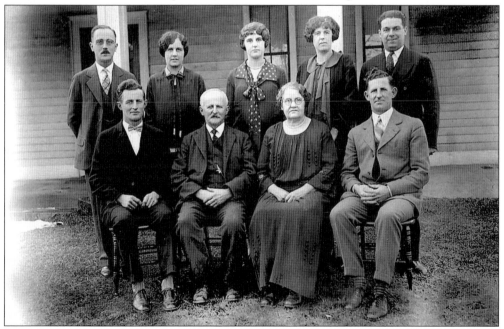

Edward W. Theinert, the son of German immigrants, and his wife, Louise (Frantz) Theinert, first moved to the farm in 1902. They eventually purchased it from Henry Hartwell Jencks in 1905. From 1902 to the mid-1940s, the family made Albion their home. This rather formal photograph of the Theinert family was taken in the mid-1920s. Pictured are, from left to right, the following: (seated) William, Edward, Louise, and Walter; (standing) Charles, Ann, Lillian, Rosalie, and Mr. Paul Schwarze.

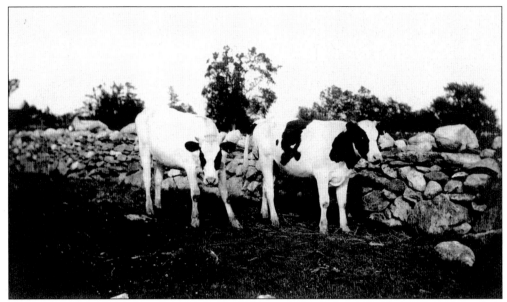

Herds of cattle roamed the pastures of Albion for more than a century. There was a time when there were far more dairy and beef cattle than people in Albion. The residents of the heavily populated cities of Providence, Pawtucket, and Central Falls depended on the farms of Lincoln, Cumberland, and other outlying communities to provide them with meat, dairy, produce, and other food supplies. Many of the fieldstone walls formerly used to corral livestock still can be seen throughout the town of Lincoln.

This is the former Theinert dairy barn as it appears today. The last reminders of a thriving dairy industry in Albion are the former Theinert Farm stone barn and the stone walls that run alongside the west side of Old River Road, between School Street and the bridge over Route 295. All the stonework associated with this former farm was created or maintained by Walter Theinert, who, in addition to all else, was a skilled and masterful stonemason.

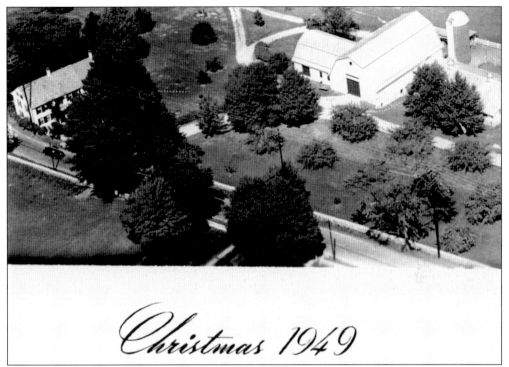

Christmas 1949

This is a bird's-eye view of the Church family's Kirkbrae Farm in the late 1940s. The English translation of the Irish word *kirkbrae* is church on a hill. This holiday photo-postcard was produced by the Church family in 1949. From this aerial vantage point, the cow barn, silos, outbuildings, and home of the Church family can be seen. The property and pastures of this former farm were eventually sold, and the bulk of the property is now the site of the Kirkbrae Country Club and golf course.

The Goudreau Farm operated closer to the village center. The windmill and farmhouse of the School Street farm are visible in the background of this winter scene from 1936. The windmill powered the artesian well pump that supplied the farm's water needs. Goudreau Farm supplied eggs, poultry products, and produce for local consumption.

55

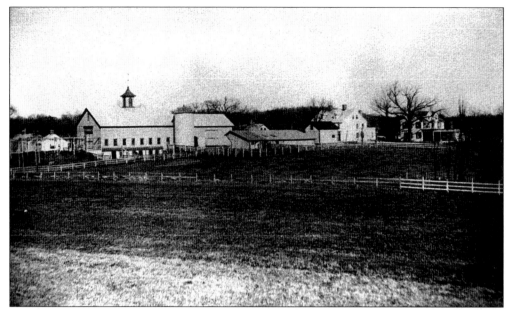

Large, open agricultural vistas were everywhere in early-20th-century Albion. This view of the Albion mill farm was taken in the early 1900s. Many mills with large land holdings maintained their own farms to supply operatives with milk and produce. Some companies had their own mill stores, where workers could use vouchers or have purchases deducted directly from their earnings. The Albion mill farm was located on the south side of School Street.

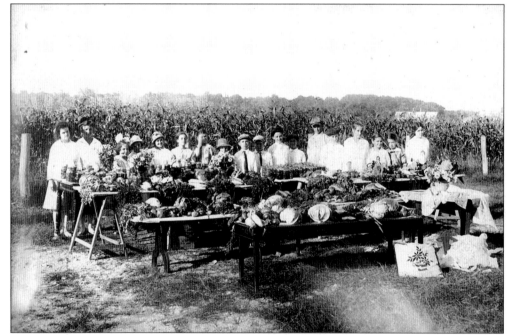

The 4-H Club in Albion was a very active organization for many years. Using the fertile land located behind the village school, members learned to grow and maintain extensive vegetable gardens. In this 1914 photograph, students proudly display some examples of their impressive prize harvest.

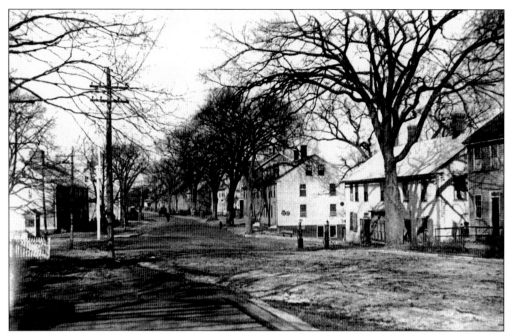

Albion's Main Street was the subject of this early-1930s photograph. The view is looking north in the direction of Manville. The paving of major town roads had not yet begun. Though some modern amenities such as electric and phone service had arrived on the scene, dirt roads were commonplace even in the late 1930s and early 1940s. The wooden structure at the edge of the road in the left foreground is a large platform scale used by the company farm, whose property extended out to the street.

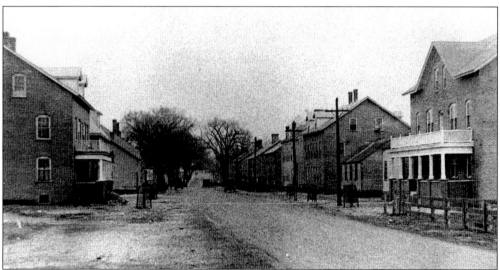

This photograph, taken during the same period as the image above, depicts a view of Main Street looking south toward the village center. Mill houses can be seen lining both sides of the road. The housing provided by the Albion mill had a decidedly different look than its counterpart's in Manville. Instead of continuous block-row housing, freestanding, multistory, wood and brick apartment houses were erected. Virtually all of the houses built by the mill company still exist, and are used as private homes today.

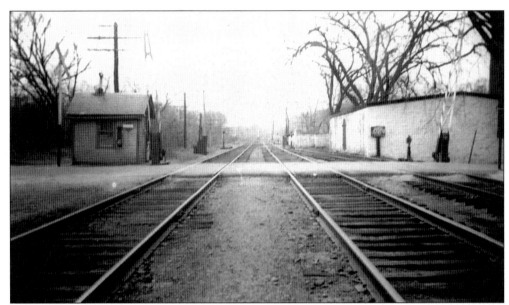

The Providence and Worcester Railroad first whistled through the small community of Albion in 1847. This 1936 photograph shows the railroad bed as it appeared when looking north from the Albion mill. There were three sets of tracks: one for northbound travel, another for trains going south, and a third used by the mill as a freight spur. The freight depot appears on the right, and the old canal gatehouse (which no longer stands) can be seen in the far left background.

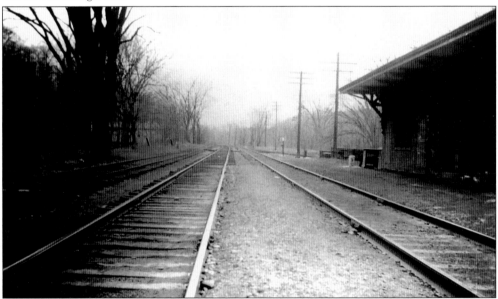

This photograph, also from 1936, depicts a southward view of the track bed. Over the years, ownership of the railroad went back and forth between the Providence and Worcester Railroad and the New York, New Haven and Hartford line. Both ran busy passenger and freight transportation operations in the 19th and early 20th centuries. In the distance, the northbound and southbound mail cranes can be seen. Situated in the left background is the small rail-crossing shanty, and to the right, a cotton warehouse.

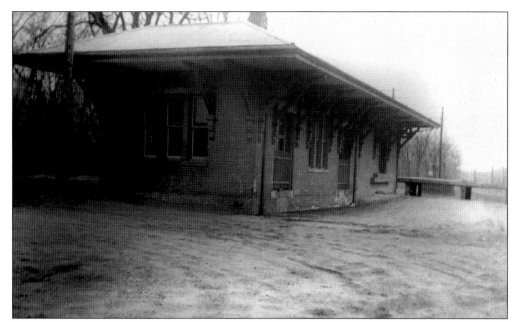

This *c.* 1847 train depot was the first building that most rail travelers and immigrants to Albion entered. Virtually all of the small village passenger depots were very similar in appearance and based on the same design. Though not as large and ornate as the urban stations, the small depots were user friendly. This depot served the village as a transportation center for approximately a century.

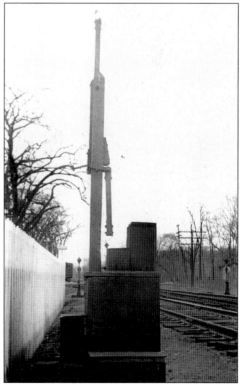

Among the valuable services the railroad provided was mail pickup and delivery. From the late 1840s to the mid-1930s, this track No. 1 mail crane allowed nonstop trains to hook and retrieve outgoing mail in the village of Albion. In the early 1950s, the Providence and Worcester Railroad removed all but one section of track. Today, that single remaining section of track provides for both northbound and southbound freight transportation and an occasional sightseeing tour.

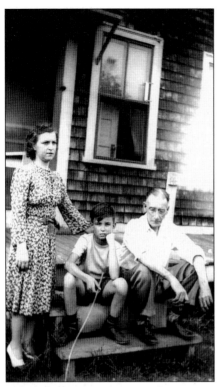

Most non-farming families in Albion made a living directly or indirectly from industry. In this photograph are, from left to right, Claire (LaFrance) Bishop, her son Theodore Bishop, and her husband, James Bishop. Claire Bishop spent many years working at the mill, starting her career in the cloth room before becoming a payroll clerk and bookkeeper for the spinning department. James Bishop was the railroad agent for the New York, New Haven and Hartford line. This photograph was taken on the steps of the Bishops' School Street residence in 1941.

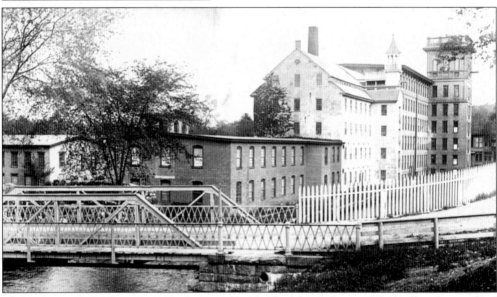

This image is from a rare *c.* 1900 photo-postcard. The physical size of the mill is the result of numerous and very large additions by a number of subsequent owners. The rubblestone mill in the center, with its very distinctive pointed bell tower, was constructed in 1823. A brick north wing was added in 1850, and a south wing in 1856. The original rubblestone structure stood until 1908, when it was torn down and replaced with the brick mill building that is so familiar to residents today. In recent years, the former mill has undergone massive renovation. It is now a modern condominium complex.

Much of the day-to-day work associated with a textile mill was physically intensive, as this late-1930s photograph shows. Most mill village children were employed by the mill when they reached adulthood. The Valley Falls Company and its successor needed able-bodied men to unload and wheel heavy, compressed bails of cotton up the ramp and into the mill, where it was transformed into fine-quality cloth.

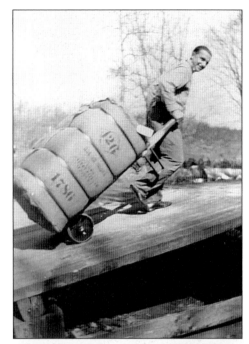

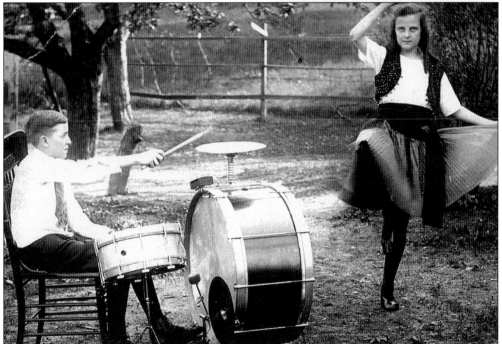

Margaret Erskine is seen practicing the Spanish dance in this *c.* 1915 image. Providing a beat for the dance is young Wallace Bishop, Albion School Orchestra drummer. Margaret was the daughter of William Erskine, local senator and mill superintendent of the Valley Falls Company, which acquired the Albion mill in the 1850s. Mr. Erskine cared for his community, and was instrumental in the company's decision to beautify the village by planting trees and upgrading the appearance of streets and existing buildings.

Dr. Charon (left) was the village medical doctor for both Albion and Manville during the 1930s and 1940s. Standing with him is railroad agent James Bishop. Medical housecalls were routine occurrences until the latter half of the 20th century.

Dr. George Kokolski Sr. resided in Manville, but he carried on the long tradition of the housecall in the northern villages for decades. He was the last of Lincoln's village physicians to do so. Both Dr. Charon and Dr. Kokolski provided an invaluable service to the residents of Manville and Albion. Needless to say, the physicians were highly regarded members of the community.

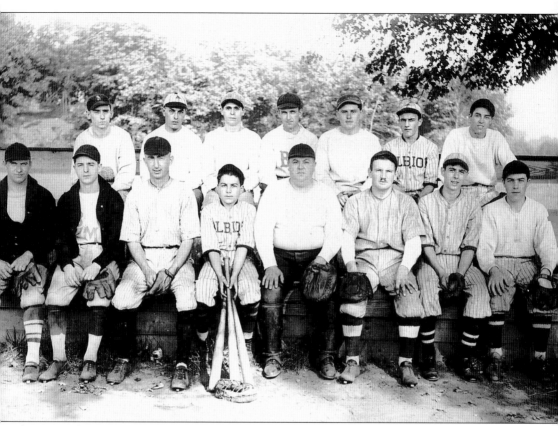

Shown in this 1927 championship photograph are members of the Albion Businessmen's Baseball Team. There were three teams trying to capture the village pennant that year. The other two teams were the Spinning Room team, which came in second, and the Card Room team. Members of the Businessmen's squad are, from left to right, the following: (first row) Fred Page, pitcher and center field; John Lambert, third base and shortstop; Jacob Garber, second base; Mathew Cipriano, mascot; Aritise Poissant, center field; Antol Lozeau, first base; ? Gertin, left field; and William Gagne, left field; (second row) Theodore J. Bishop, right field; Telesphore Daneault, right field; Paul Poissant, third base; Charles Erskine, pitcher; Amand Poissant, center and right fields; Delard Gagne, left field; and William Goudreau, shortstop.

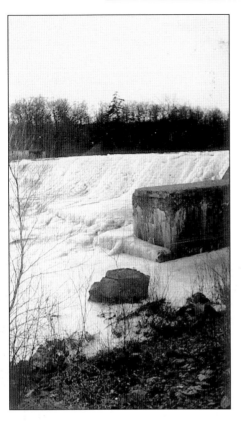

Like other parts of Rhode Island, the little village of Albion was battered by extreme weather in the 1930s. Locally, the worst years were 1936 and 1938. In 1936, the combination of extremely cold midwinter temperatures and months of accumulated frozen precipitation in northern Rhode Island resulted in lower water levels and slowed the current of the Blackstone River. The result was captured in this image of the Albion dam with its waterfall frozen virtually solid.

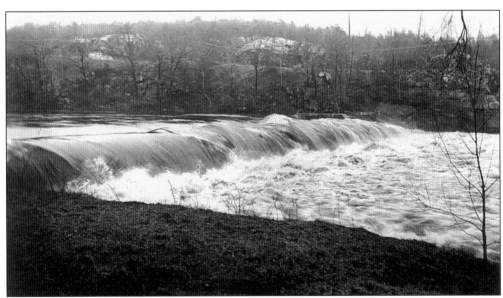

This is a view of the Albion Dam during the freshet of 1936. A sudden spike in temperature accompanied by heavy rain produced an unusually rapid thaw in March 1936. The combined occurrence produced a disastrous flood. In this image, the Valley Falls Company dam is barely visible, producing a mere bump in the water level of the Blackstone River.

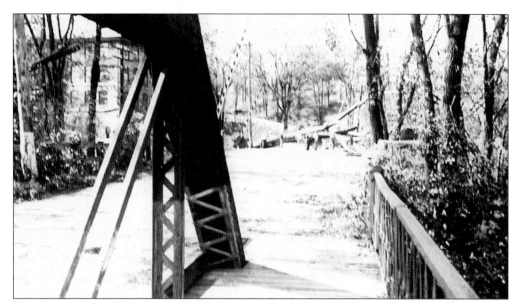

The great unnamed hurricane of 1938 likewise brought devastation to the small village and its mill. Packing winds of almost unimaginable strength and heavy rain, the storm brought down trees by the hundreds and caused incredible property damage. This photograph, taken from the Cumberland side of the bridge in Albion, shows the Blackstone River passing through the cast-iron railings and over the bridge deck. A huge fallen tree is also visible in the background.

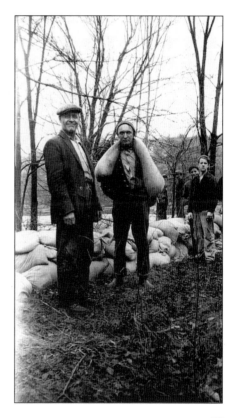

Mill operatives and volunteers filled and piled thousands of sandbags in an effort to protect the Albion mill complex and other structures near the river from being inundated by the rising water in 1938. The river continued to swell until it was more than a dozen feet over floodstage. In spite of the workers' best efforts, the floodwaters eventually swept past the sandbags, inundating the warehouses and mill.

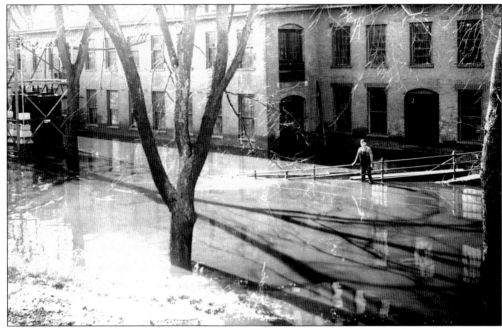

This surreal image shows the west side of the Albion mill in 1938 as the flood began to recede. It was weeks before operations could resume with any sense of normalcy. The financial costs of pumping out floodwaters, restoring electrical power, and repairing and replacing damaged or destroyed equipment and inventory was staggering.

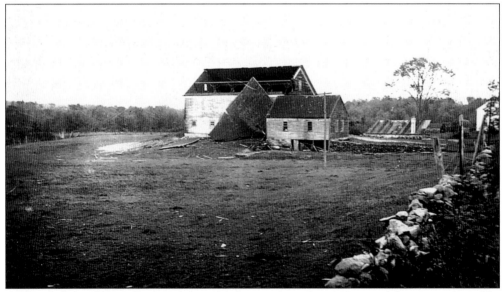

When residents ventured out to survey the damage from the 1938 storm, they were greeted by scenes much like the one in the image above. The hurricane's powerful, sustained winds fully removed one half of the large Goudreau Farm barn, as documented in this photograph. No living person in New England had ever experienced a hurricane of similar magnitude. All the villages were hard hit, especially those located along the banks of the Blackstone River.

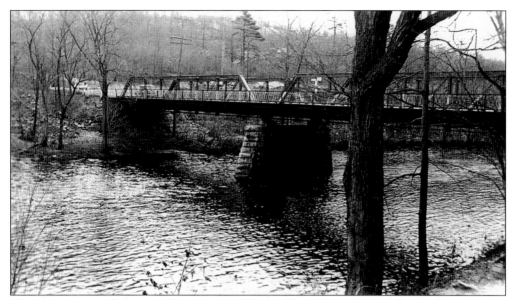

More serene times did eventually return to Albion village. This photograph was taken after the river receded to its normal level. This scene shows the waters of the Blackstone flowing well below the surprisingly undamaged 19th-century bridge. This iron bridge and its smaller counterpart underwent extensive restoration in recent years.

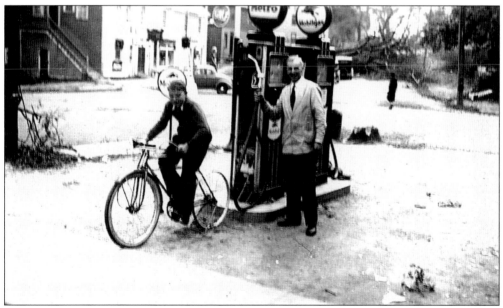

For some time after the 1938 hurricane, the village of Albion had no electricity to power the gas pumps. Undeterred and resilient residents adapted a bicycle to work the pumps. This petrol station was located in the village center at the corner of Main and School Streets. For generations this corner was a gathering place for discussion and story swapping by villagers, and it is now the location of a "Lil General" store.

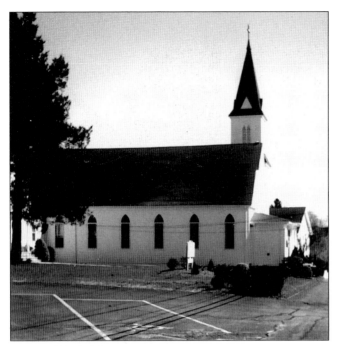

St. Ambrose Catholic Church is a wonderful example of a late-19th-century country church. Located on an elevated section of School Street, the well-preserved white clapboard exterior and steep, pointed bell tower of the church can be seen from most areas of the village. French-speaking Roman Catholics, lured by employment prospects at the mill in the 1800s, quickly dominated the language and culture of Albion. They formed St. Ambrose Parish in 1892, and constructed this church six years later.

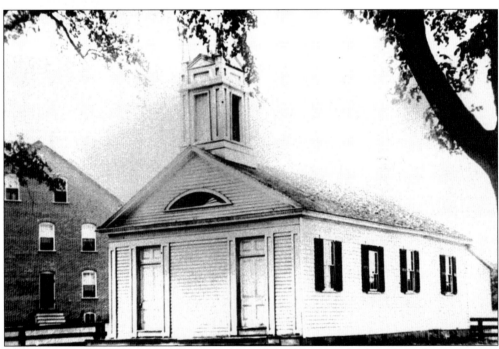

Fireman's Hall, a 19th-century Greek Revival–style building, was built on land donated by the mill. Located on School Street, it is a familiar historical landmark of the village. Like the Fireman's Hall in Saylesville, the Albion structure served the community as a center for public business and social gatherings. Prior to the construction of St. Ambrose Church, local parishioners held services in this building. Considerably altered in the last century, it is now owned and used by the town as a Parks and Recreation Department youth center.

Fireman's Hall and its former belfry also can be seen in the background of this Labor Day photograph taken on School Street in the 1940s. Pictured at center right is "Captain" Gerry Goudreau of the Goudreau Farm, whose barn had lost its roof in the 1938 hurricane.

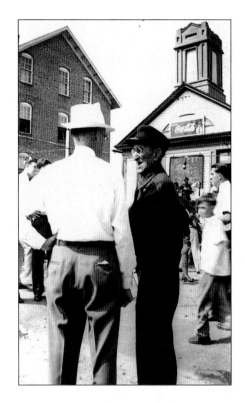

Taken around 1940, this photograph shows longtime Albion resident Ben Newman. Although he owned a great deal of land in and near present-day Kirkbrae Estates, Newman often was seen about the village asking merchants for old bread. Open land was plentiful then and prices were low. Little could Newman have imagined the staggering figures his property would be worth today.

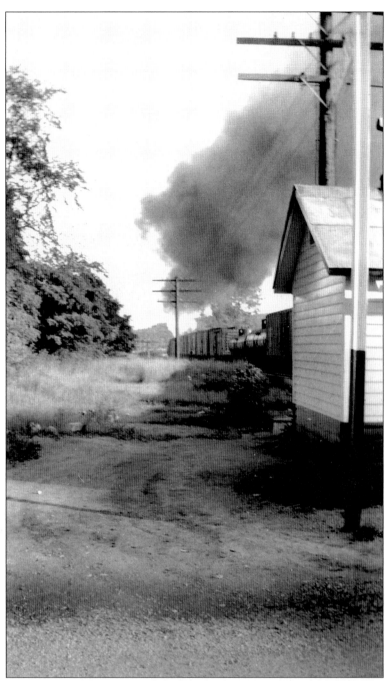

The last of the passenger locomotives, known for their large plumes of diesel smoke, passed through Albion in 1959. The Providence and Worcester Railroad continues to operate this profitable line through the village, but now transports freight and not passengers. The track bed is kept in excellent repair, and it has been restored routinely by the company over the years. The state of Rhode Island recently constructed a bike and walking path along the river in this area. The recreational path basically runs parallel to the railroad tracks, and is located a short distance away from the rails.

Four

LIME ROCK
AND QUINNVILLE

It is quite possible that Roger Williams or members of his original party were the first to discover the limestone deposits of the North Woods when the territory was surveyed, before the land was purchased from the natives. The discovery occurred, perhaps, by accident while early settlers searched for farmable tracts of land in the area of *Loqucesit*. The location eventually assumed the name of Lime Rock due to the presence of the very important natural resource. This quarry village was indeed the site of one of America's first and longest-continuing industries.

The activity of liming, as it was called, dates from at least the 1660s. The conversion of raw limestone into quicklime, a prime ingredient of quality Colonial plasters and mortars, proved very profitable to the locals.

Farming the naturally rich and acid-free soil was a main occupation of local settlers before, during, and after the advent of the limestone industry. The village had more than a dozen farms at the height of its agricultural period, and was the headquarters of the local Grange.

Lime Rock is also the home of some of Lincoln's earliest Colonial dwellings, such as the Capt. Valentine Whitman Jr. stone-end house, the site of the first official meeting of the Town of Smithfield. The fact that the village was situated along Great Road also made it a popular stopover for weary stagecoach travelers.

Quarrying continues in Lime Rock to this day, and the village still retains the appearance of a rural community. Horses and cattle still can be seen in some fields, and the community is by far the most quaint and pastoral of all of Lincoln's villages. Due to its history and remarkable significance, Lime Rock has been placed on the National Register of Historic Places.

Quinnville, originally called Old Ashton, was established as a small mill operation near Pray's Wading Place. One small cotton mill, the Smithfield Woolen and Cotton Manufactory, and a few millhouses were built c. 1813 on land purchased from Simon Whipple. Wilbur Kelley, a former ship captain, tried his hand at manufacturing in the village, but the textile industry in Quinnville never really got off the ground.

Quinnville also can lay claim to having provided kilns, wood, and manpower to Lime Rock's early lime industry, and boasts a well-preserved section of the Blackstone Canal. The village is now home to a state park visitors' center housed in Wilbur Kelley's former home.

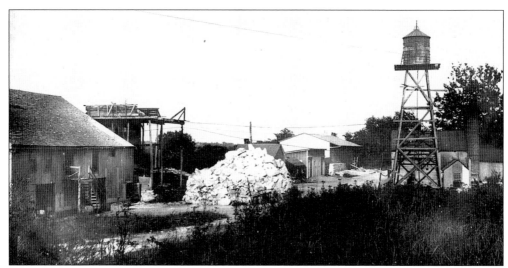

This is a view of the Dexter quarry as it appeared in 1910. Stephen Dexter first settled in Lime Rock in the 1670s and began the Dexter family's long tradition of lime burning. Located in the area of Dexter Rock Road, his family's quarry and the Harris family's quarry in Lime Rock dominated the local lime industry. From the very beginning, nearby farmers benefited financially by the presence of limestone. Farming was seasonal, and during slower times of the year farmers earned extra income by working in the quarry, or by using their wagons to transport cut wood or quarried stone to the lime kilns and to the finished quicklime market.

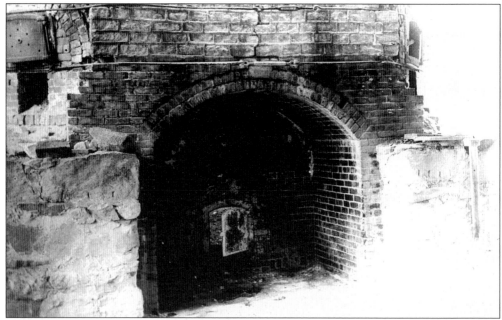

This is a c. 1900 photograph of an arched lime kiln. The earliest kilns were primitive slab-stone-and-earthen structures. Construction techniques varied depending on the time period and available materials. Some early kilns looked like stone caves, and others like small volcanoes. All kilns had a place to put in wood and limestone from above, and an arched opening at the bottom from which to shovel out the burned lime. Most 19th- and early-20th-century kilns were made with brick, and later brick and iron.

The document shown at right is a bill drawn up in 1815 for casks of quicklime. At that time, quicklime was going for one dollar a barrel, which was a substantial sum in the early 1800s. The account was between Henry Jenks and S. G. Martin. Lime also was used for bartering and as a medium of exchange to pay off debts. Lime Rock village and all of what would become Lincoln were still part of the town of Providence when this bill was written.

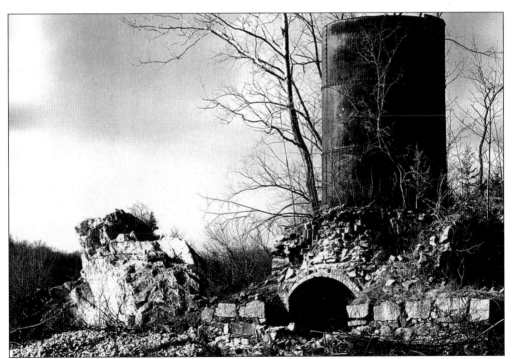

The evolution of kiln building is evident in this photograph of a more recent lime kiln. The village of Lime Rock was named after the natural mineral resource that was discovered here. Burned limestone, or quicklime, was a consistently valuable commodity. The rapid rise in home building only fueled demand for the product. By the 1800s, liming was big business and Lime Rock was an important commercial center in Smithfield, with its own bank, hotel, taverns, and stores.

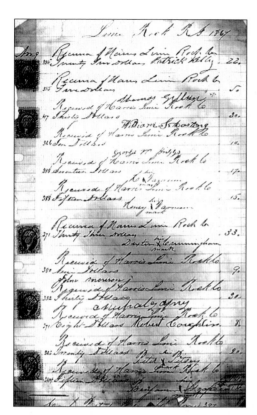

The Smithfield Lime Rock Bank held the deposits of most of the families involved in the lime industry. Interest payments were recorded by attaching interest stamps. The 1865 bank record at left shows deposits posted to the Harris Lime Rock Company. About half of the depositors could not write, but affixed their mark instead. Bank officers signed for the depositors afterward. Bolstered by quarrying activity, the village of Lime Rock prospered without a textile industry.

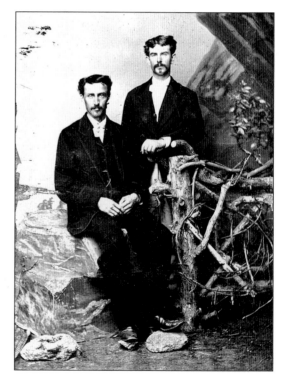

The Haskell brothers, Richard (left) and Daniel, were full-time limers. One Sunday the men donned their best, and took a rare jaunt to Providence. While there, they posed for this rather formal c. 1870s tintype photograph at the Arcade, the country's first indoor mall. Unmarried lime quarrymen had a reputation for leaving the village on their free days (pay in hand) to relax, so to speak. Providence and Harrisville were two of the most popular destinations.

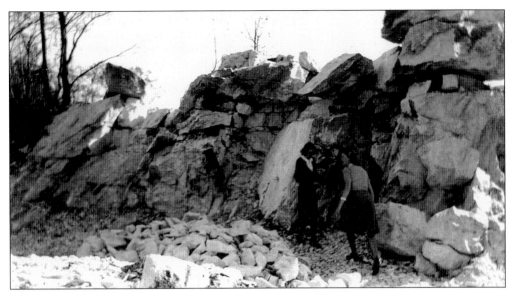

In this 1940s photograph, Dorcas Northup (left) and Esther (Curtis) Wilbur are seen hiking about the giant blocks of limestone at the Middle Hill Quarry in Lime Rock. In preparation for burning or processing in a stone-crusher, limestone boulders and slabs were broken into smaller pieces that were easier to handle.

After the ledges of limestone had been consumed, limers resorted to open-pit mining. Later, explosives were used to loosen the stone. The removal of vast quantities of rock created enormous lime pits in the quarry areas. After being abandoned, the pits filled with water, creating deep picturesque ponds, framed by the remains of white limestone outcroppings.

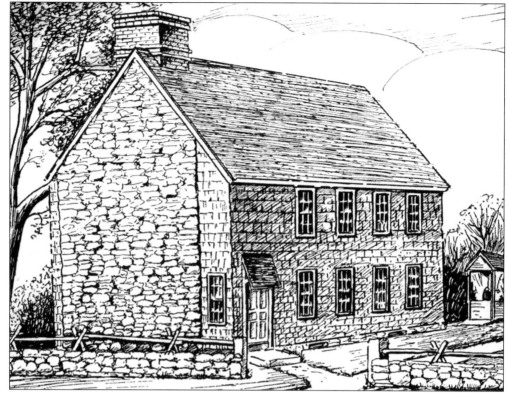

The *c.* 1690 Capt. Valentine Whitman Jr. House is located at the corner of Great and Meeting House Roads. In 1730, the Colonial stone-ender was the site of the first town meeting of Smithfield. Though the current house dates from the early 1690s, there are some references that point to the possibility that an earlier house may have been located on this site. Whitman's father had one of the first houses in Lime Rock, but it was burned in the Indian War of the 1670s. Only the chimney was left standing. Some people believe this house was rebuilt around that chimney.

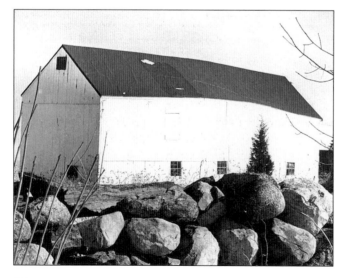

This is a view of the Whipple-Cullen Farm's enormous barn on Old River Road. The homestead and farm date from *c.* 1736. In the 19th century, John Cullen bought the large farm from the Whipple family. The well-preserved homestead is still owned by John Cullen, great-grandson of the original buyer. Cullen and his wife, Barbara, host visitors at the Colonial farmhouse on the property, which is now a bed-and-breakfast and home.

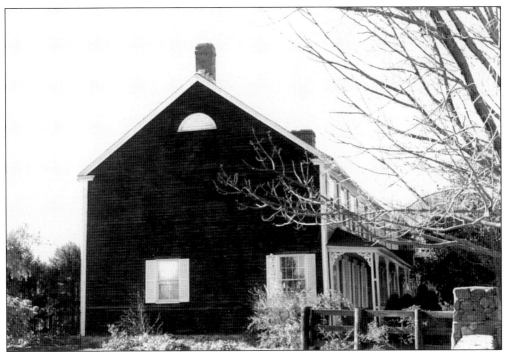

Pictured above is Nathaniel Mowry Tavern, which served as a popular stagecoach stop for travelers heading to and from Providence, Worcester, and other destinations. Maj. Nate Mowry kept the tavern going from 1817 to 1841. The original sections of the rambling house date from c. 1800. Members of the Mowry family were well established in this area as early as the 1600s. Major Mowry was a well-respected member of the Rhode Island militia and the community. He was also an accomplished auctioneer and known to be well versed in legal matters.

Pictured above is an 1875 postmaster receipt from the Lime Rock post office. During the 19th and early 20th centuries, Lime Rock had its own post office. The Lime Rock post office was initially operated out of private homes in the village center. By the 1870s, the office found a more permanent home at Perkins Store on Great Road. Mr. C. H. Perkins served as the village postmaster for many years, and his signature appears on this document.

This c. 1885 photograph shows the Jackson family of Lime Rock in front of their home on the top of Molasses Hill on Great Road. The Jackson family also has deep historical roots in Lincoln. Thomas Y. Jackson was a Quaker elder at the Saylesville Meeting House and a master mason. Pictured in this early homestead photograph are, from left to right, the following: (front row) Thomas Y. Jackson Sr., John H. Jackson, Joseph Jackson, unidentified, Sarah (Oddie) Jackson, Thomas Y. Jackson Jr., and Stonewall Jackson; (on porch) Alice O. (Halliday) Jackson and Sarah (Wilbur) Jackson.

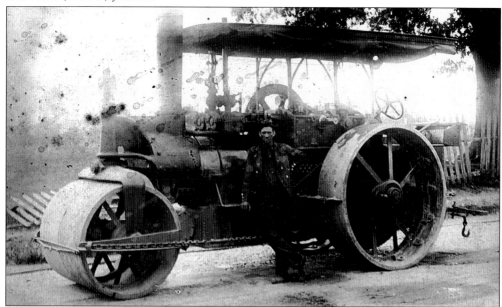

John H. Jackson was the road commissioner of the Lime Rock district in Lincoln early in the 20th century. This c. 1900 photograph shows Jackson standing in front of a true steam-powered roller. Prior to the centralization of Lincoln public works services, each village had its own commissioner and truck to plow and maintain unpaved roads. For large projects the road commissioners would combine labor and equipment. John H. Jackson's district covered the largest surface area of the town.

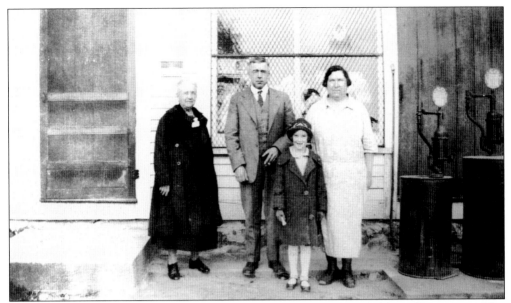

Frank W. Curtis operated his general store on Great Road in Lime Rock's village center. This photograph was taken in the front of the Curtis store in the 1920s. Appearing in the photograph are, from left to right, Ella Mowry, owner Frank Curtis, Esther (Curtis) Wilbur, and Frank's wife, Carrie Curtis.

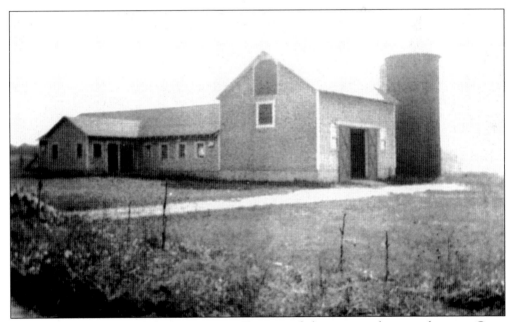

The Jordan family owned the Nate Mowry Tavern and the associated acreage between Great Road and the present limestone quarry for many years. They operated a large dairy farm on the property. This early-20th-century postcard depicts the Jordan family farm's cow barn and silo.

This Grange ceremonial photograph from the late 1940s was taken at the headquarters of the Lime Rock Grange, now North Gate, on Old Louisquisset Pike. The Lime Rock Grange No. 22 Patrons of Husbandry was formed in the 1800s. A social organization of farmers, the Grange first met at the house of Ira Angell on Great Road. In 1904, the group acquired the *c.* 1807 Louisquisset Pike Toll House and made it their permanent headquarters. Shown in this image are, from left to right, Anna Tucker, Everett Wilbur, Louis Rivet, and Alvin Tucker.

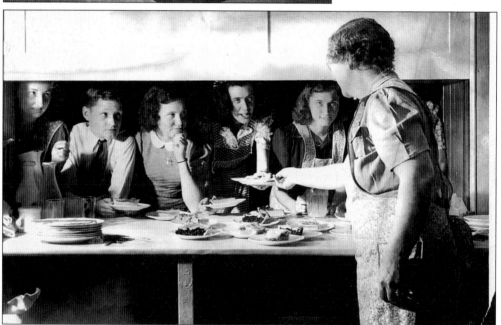

Despite wartime distractions, the Lime Rock Grange sponsored one of its famous harvest suppers in 1942. A wonderful dinner with all the fixings was finished off with delicious home-baked pies. Standing in the foreground is Barbara Jordan, who was in charge of the kitchen. Lined up at the window are her assistants, from left to right, Jean King, Lawrence Colerick, Mildred Colerick, Susan Verdon, and Doris Perry.

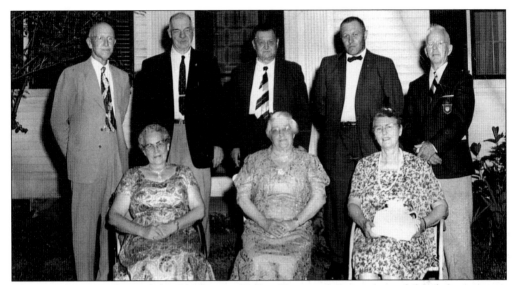

The founding members of the Blackstone Valley Historical Society posed for this picture in 1958. Shown here are, from left to right, the following: (seated) Mrs. Chester Follett, Mrs. Irving K. White, and Mrs. Paul Barnard; (standing) Paul Barnard, Chester Follett, Dr. Brewer Marshall, Robert Simpson, and John McCabe. The idea of forming a local historical preservation organization was discussed among a group of concerned citizens from a number of local communities, including Lincoln. (BVHS.)

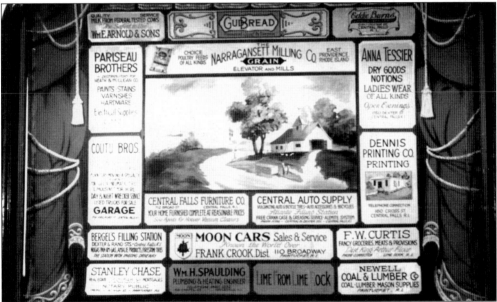

This is a photograph of the fully restored, hand-painted canvas advertising stage curtain installed by the Grange at the North Gate Toll House on Old Louisquisset Pike in Lime Rock, Lincoln. The 1925 illustrated curtain is a rare surviving example of the artwork produced by the Anderson Scenic Company. Surrounding the pastoral scene in the center are painted advertisements from local merchants. The ads covered the cost of the curtain's production. The Blackstone Valley Historical Society restored the curtain when the organization acquired the building from the Grange in 1971.

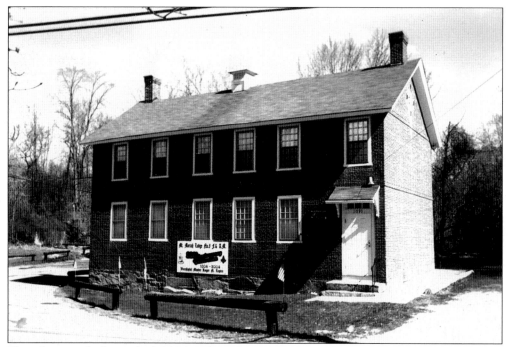

This photograph shows the Mt. Moriah Lodge on Great Road as it appears today. Portions of the building likely date to the late 1700s. It served as a one-room schoolhouse at one time. In 1804, the building was extended and bricked. A second story was added at the request of the Lime Rock Masons, who still use the building as a lodge. The Masons celebrate their 300th anniversary in 2004.

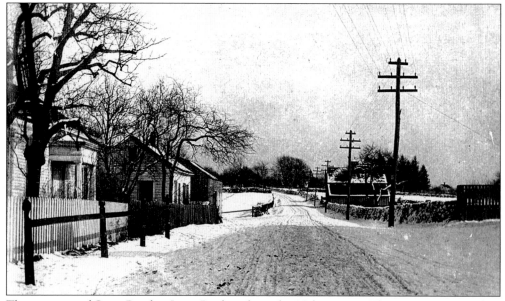

This is a view of Great Road in Lime Rock early in the 20th century. This wintry image, taken in 1901, shows how open and undeveloped this stretch of Great Road was at the time. On the left are horse hitching posts, a sure indication that cars and trucks had not yet arrived on the scene. On the right side, in the distance, is a very large hay barn.

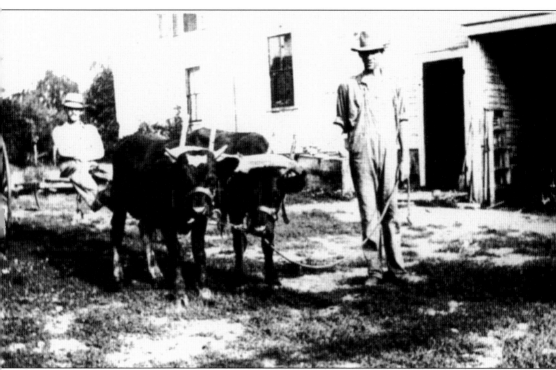

Though they had careers in other areas, members of the Jackson family have always dabbled in some form of farming, and have particularly enjoyed raising domestic animals. In this c. 1910 photograph, John Jackson is training his two oxen calves to power a buggy. These docile animals eventually grew very large, and were able to pull heavily laden wagons with ease. The Jackson family of present-day Lime Rock continue to maintain an assortment of domestic animals on their properties, including horses. The presence of horses and cattle maintained by some of the inhabitants of Lime Rock have helped to preserve the village's rural appearance.

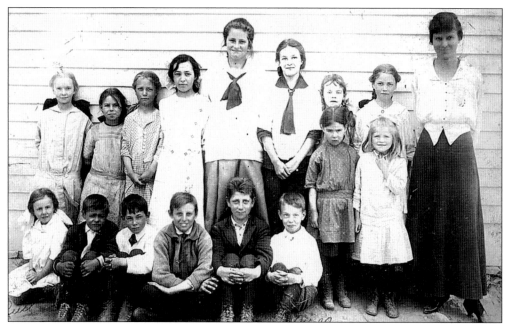

This is a *c*. 1918 photograph of Pullen Corner School mistress and principal Estelle Collier (far right) with her class. The small, one-room schoolhouse was nicknamed "the boiled potato school" by a visiting superintendent, who was amused by the fact that the children boiled potatoes for lunch on a pot bellied stove. This and other one-room schools in the area closed their doors in the early 1920s, when the new community school opened. In the front row, seated farthest to the left is Ruth Sonner, and seated farthest to the right is Walter Sonner.

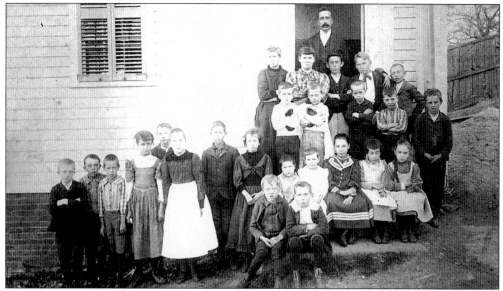

The Lime Rock School had been open for about 30 years when this photograph of Schoolmaster Ernest Wilbur, standing in one of the school's two doorways, and his students was taken in 1890. Among the students posing with their classmates are Bertha L. Curtis (seated on the school steps third from the right) and future Lime Rock schoolteacher Elizabeth E. Northup (second from the left in the back row).

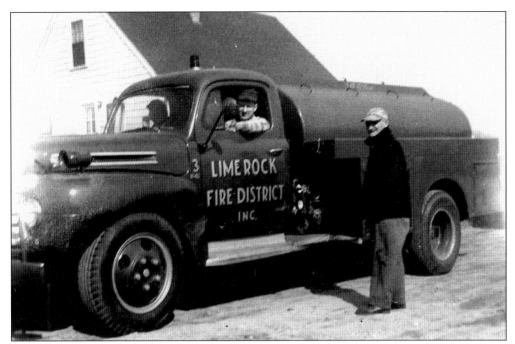

The Lime Rock Fire District began its history as a volunteer department made up of Grange members. The first station, opened in the 1920s, is now a museum on the grounds of North Gate on Louisquisset Pike. In addition to the Charger, one of the department's finest early fire trucks (not shown), the district purchased other vehicles. Standing alongside this 1950s tanker is Lime Rock Fire Chief Henry Jordan Sr. Behind the steering wheel is Firefighter Tucker.

The village of Lime Rock eventually opened two new, more modern fire stations—one on Great Road, and one on Twin River Road. This is a photograph of the Great Road station that replaced the obsolete firehouse on Old Louisquisset Pike c. 1952. The second station is the most modern and is situated at the south end of the village.

State Ballet of Rhode Island principal dancers Mark Marsden and Mia Nocera of Lincoln are seen rehearsing an upcoming performance at the Brae Crest School of Ballet in Lime Rock. A cultural landmark of the village, the school has been producing exceptional dancers for almost half a century. Founded by Herci and Myles Marsden, the Sherman Avenue school is the home of the State Ballet of Rhode Island.

In this pre-millennium photograph, Lincoln residents are seen surveying the new 59-acre Lime Rock Preserve. The land was purchased to maintain the natural beauty of Lime Rock. By the late 20th century, the era of agriculture drew to a close. The children of local farmers found new careers outside of the village. Fields that had been plowed and seeded for more than a century were left undisturbed. For the most part, the open pastures surrounded by stone walls are now filled with trees or have been developed.

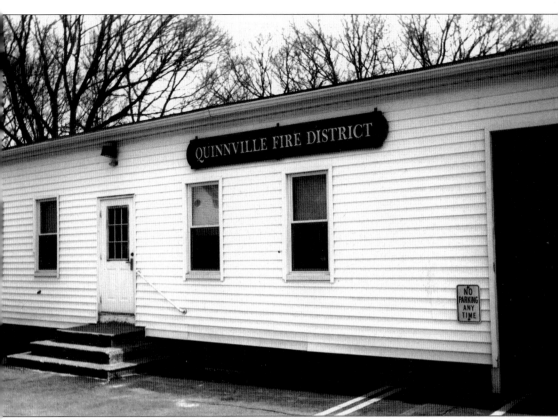

Though it is a small district, Quinnville established its own volunteer fire department to protect its community. In addition to providing service to Quinnville itself, the firefighters and equipment of the Quinnville Fire Department provide mutual assistance to surrounding villages when necessary. This 1930 firehouse is situated on Lower River Road.

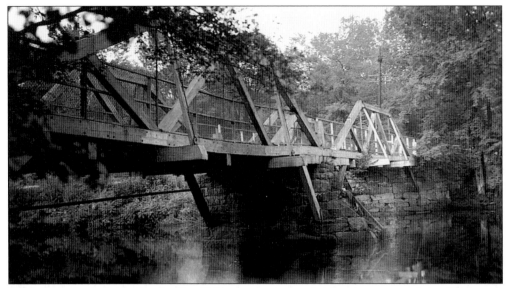

This photograph shows the Berkley Bridge, a pony-truss bridge that spanned the Blackstone River in the 1920s. Its location is roughly 100 feet south of Martin's Wading Place and the c. 1708 road that used to run through Quinnville to Lime Rock's Great Road. This more modern bridge was a convenient route for village residents who worked at the Berkley Mill in Cumberland. This bridge was replaced with a heavy, wooden-trussed camel-back bridge in 1947.

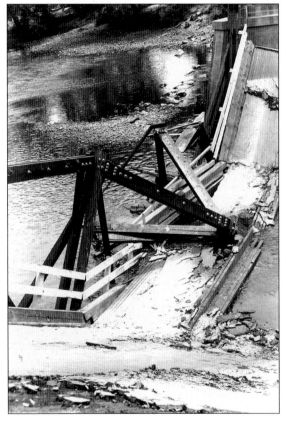

In 1956, a heavy truck caused the collapse of one half of the Berkley Bridge. This is a view of the bridge as it appeared after the collapse. It took time, but the Berkley Bridge was repaired. The old Ashton Bridge, at the opposite end of Quinnville, was destroyed by the river's floodwaters during Hurricane Diane in 1955 and never was replaced.

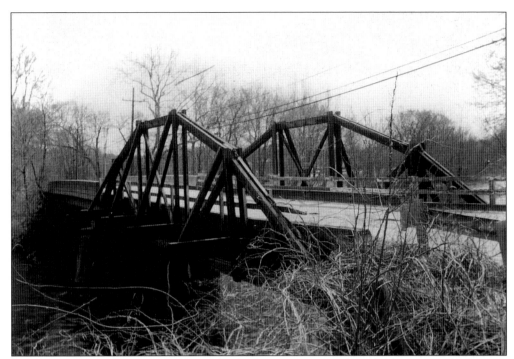

This is a view of the Quinnville-Berkley bridge as it appeared at the beginning of the 21st century. In 1969, the town of Cumberland replaced the eastern portion of the camel-back bridge with a metal version. The remaining camel-back span on the Lincoln side closed in 2004, pending the installation of a new bridge over the canal. The new bridge is expected to resemble the historic pony-truss bridge of years ago.

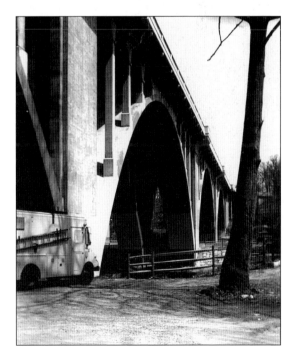

This is a view of the recently restored arches of the Ashton Viaduct bridge. In some places the bridge climbs 160 feet above the Blackstone River. All traces of Quinnville's original small cotton mill were, at the very least, buried during the bridge's construction. Quinnville was originally called Old Ashton, before residents chose the new name of Quinnville to distinguish their community from Cumberland's village of Ashton. Construction on the viaduct began in the 1930s. The bridge sits high above Quinnville, though there is no direct access to it from the village.

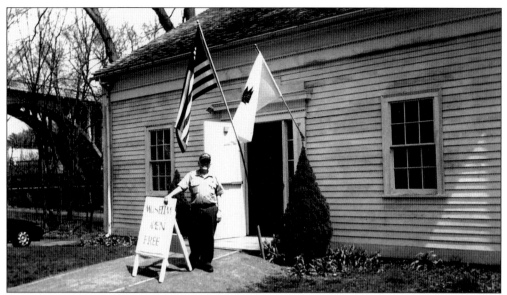

This early-19th-century building is the Capt. Wilbur Kelley House, which is located at the end of Lower River Road in Quinnville. Captain Kelley was a retired ship's captain. In his career he piloted ships for the Brown family of Providence, including the *Ann & Hope*. Kelley purchased the small wooden cotton mill here c. 1820, when the area on this side of the river was known as Old Ashton. This building is now a state park visitors' center. The gentleman in the foreground is Park Ranger Albert Klyberg.

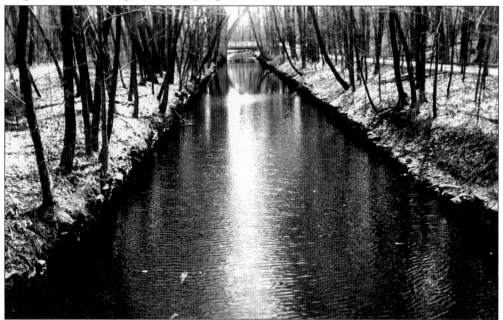

This is a view of a well-preserved, completely straight section of the Blackstone Canal as the river passes through the Quinnville district. The excavation of the canal and stonework were performed by Irish workers. Capt. Wilbur Kelley probably had high hopes for the success of his cotton mill, which sat at the very edge of the canal. The Lonsdale Company eventually bought the small mill from Kelley, but its use was minimal.

Five

LONSDALE

The history of the village of Lonsdale is one of extraordinary industrial growth. Lonsdale's long history of expansion began in the late 1820s. Nicholas Brown and Thomas Ives were able to procure a very large area of undeveloped land along the Blackstone River, opposite William Blackstone's Study Hill homestead.

In very quick succession, plans were formulated, foundations laid, and construction of a mill commenced in 1832. Construction of a second mill was begun just as the first was being completed, and a bleachery was added soon after.

So large were the holdings of the Lonsdale Company that its operations extended eastward across the river into Cumberland, and northward to Quinnville. Brown and Ives continued to operate the company until 1852, when ownership was transferred to the Goddard brothers. The brothers continued to build on Brown and Ives's success.

The Lonsdale Company was instrumental in the development of its mill village. Housing for workers, as well as land for schools, churches, a post office, and the new town hall were all provided by the company. The Lonsdale Company also contributed building materials and financial aid for almost all public construction within the village over many years.

Presently, Lonsdale remains one of the busiest villages in the town. Though primarily residential, the community contains a wonderful assortment of historic structures and a healthy commercial district. Many of the original millhouses are now private residences, and a variety of small, independent merchants occupy parts of the former Lonsdale Company mill complex.

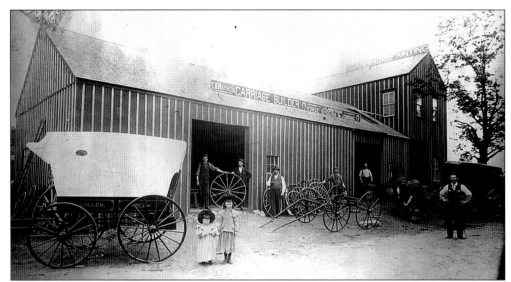

This image of the T. B. Maynon Carriage Shop in Lonsdale dates from 1904. This carriage builder operated out of the rear of Anderson's blacksmith shop. James Anderson can be seen standing at the far right of the photograph. This combined carriage and blacksmithing operation in Lonsdale was definitely one of the area's largest. The unusual small covered wagon-carriage to the left bears the name Cullen, and likely was built and ornamented for the Cullen-Whipple Farm.

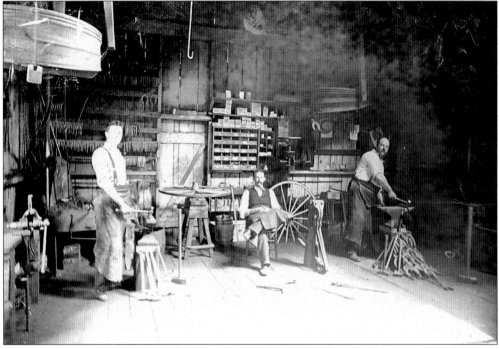

This is an interior view of the James Anderson Blacksmith Shop. This master blacksmith owned and operated the shop until its closing in the 1920s. It was located at the corner of River Road and Front Street in the area of Lonsdale known as Prospect Hill. Anderson is seated in the photograph, and his two unidentified apprentices are at the anvils.

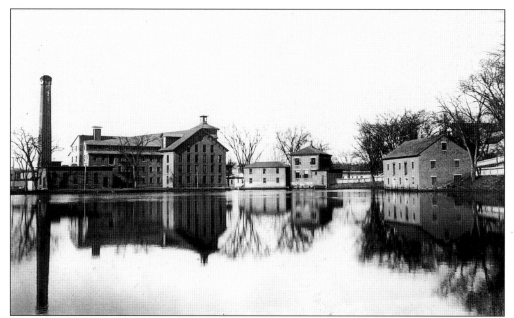

This is a *c.* 1895 view of the Lonsdale Company's production facilities and bleachery as it appeared from the opposite side of the company's mill pond. The manufacturer began bleaching its own textiles in 1844. The company continued to build more mills and expand operations long after Brown and Ives gave up their interest in the company in 1852.

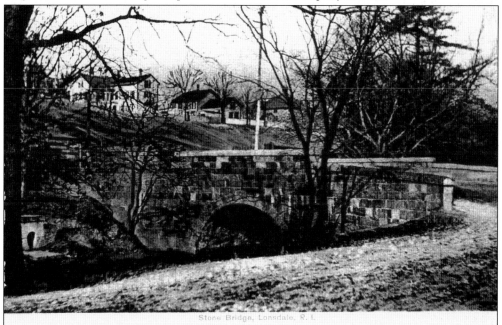

This *c.* 1906 printed postcard gives the viewer a glimpse of the "Stone Bridge," also called the Canal Bridge, on Front Street in Lonsdale. This work of art in stone is attributed to Edward Slattery. He set the granite blocks in place with incredible precision *c.* 1885. This durable stone bridge was built to provide permanent and maintenance-free passage over the former Blackstone Canal Waterway.

The presence of the old canal in its mill yard never interfered with the Lonsdale Company's expansion plans. Company engineers and builders simply sunk granite piers into the canal, and built right over it. In addition, the plant could, without extensive plumbing, directly draw water from the old canal system, or discharge wastewater into it. In time the direct discharge of pollutants into the canal, river, and mill ponds was stopped. In the decades since, substantial improvements in water quality of the Blackstone have been noted, and fish and wildlife have made a comeback.

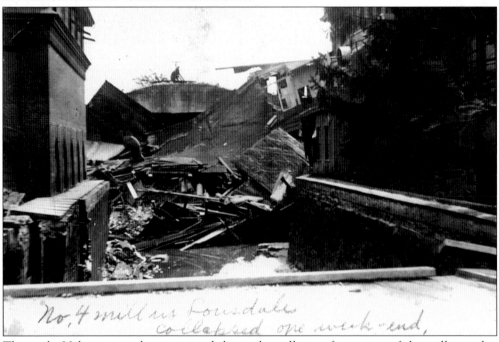

No, 4 mill in Lonsdale collapsed one week-end,

This early-20th-century photo-postcard shows the collapse of a section of the mill complex described as Mill No. 4. Apparently for no reason, a section of the Lonsdale Company mill fell into the canal over a weekend. About this time, preparations were being made to erect a giant mill on the site occupied by Mill No. 2, which was to replace a rubblestone structure built in 1832.

ost Office,
ale, R. I.

The Lonsdale Company provided the land and building to house the village's post office. This first Lonsdale-Lincoln post office originally operated on busy Lonsdale Avenue. Later in the 20th century, the federal government opened a new and more modern Lincoln post office in Lonsdale, opposite the commercial plaza on Front Street.

This 1920s photograph shows two unidentified young girls taking advantage of a beautiful day to thumb through a picture book. Many of the early-20th-century homes built west of the mill had yards and some landscaping. The image shown here was taken in a backyard garden somewhere between Pleasant and Grove Streets.

This image shows Fernand "Fred" LaBreche of Lonsdale making deliveries of fresh bread, pies, and other bakery items from his Arnold's DIVCO delivery truck in the early 1940s. Fred related that these were the first trucks the Lonsdale bakery used after Joe Arnold stopped using horse-drawn wagons for deliveries. Arnold's put a fleet of these trucks on the road.

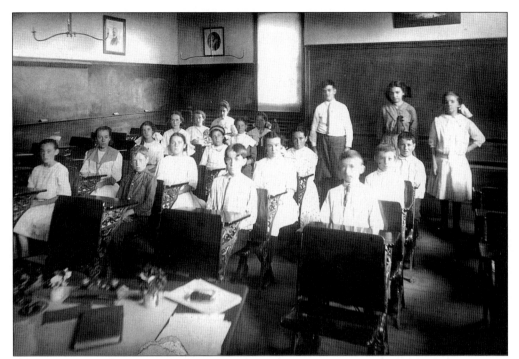

This rare photograph of an interior classroom at the original Prospect Hill School dates from the 1912–1913 school year. The first Prospect Hill School was established by the Lonsdale Company in 1884, and was located at what is now the corner of Front and Franklin Streets. It was a modest village schoolhouse with two classrooms. Lighting was provided by gas fixtures, several of which can be seen at the top of the photograph. The fact that the students were photographed indoors, and almost informally, is a bit unusual. Most class photographs were taken outdoors.

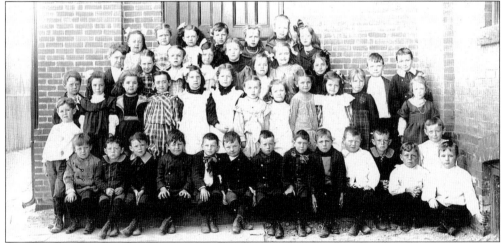

The original Prospect Hill School in Lonsdale burned down in 1915, and it was replaced with a larger two-story brick school. Classes at the new school were coeducational, but there were separate entrances and outdoor play areas for boys and girls. This more typical class photograph, taken c. 1916, shows Prospect Hill students neatly arranged in front of their freshly built brick school.

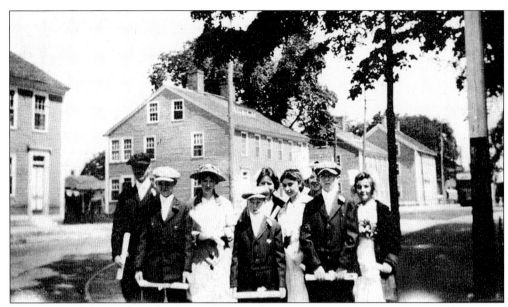

This group of nicely dressed young adults used a row of Lonsdale Company millhouses as a backdrop for this early-summer photograph in 1916. Second- and third-generation offspring of mill operatives fared a little better than their predecessors. Changing times and child labor laws resulted in better opportunities for a full, formal education.

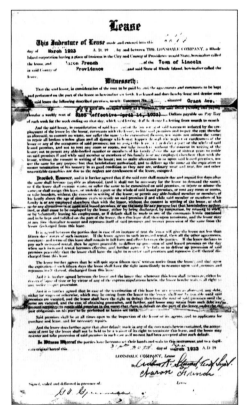

All of Lincoln's major mill companies provided housing for their operatives. The lease shown at left was typical of housing agreements signed by mill workers in Lincoln. This document was signed in March 1923, and was binding between Aaron French and the Lonsdale Company. The agreement was for the use of a brick millhouse on Grant Avenue, and the rent was listed as $185.00 per month for a single tenement. The lease renewed in December 1923 for $225.00 per month, which was a considerable amount for a mill worker in the 1920s.

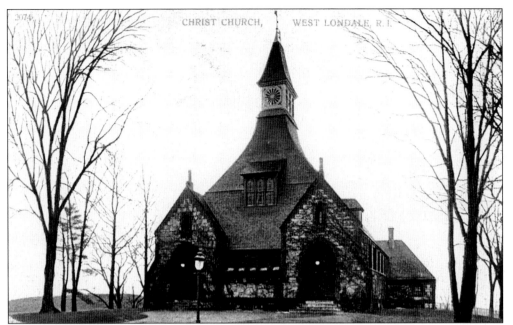

Established in 1834, Christ Church has been a spiritual anchor of the village of Lonsdale for 170 years. The congregation erected its first house of worship with the encouragement and support of the Lonsdale Company. Tragically, this early church burned down in the early 1880s. The fire was sparked by the church's furnace. The present Christ Church dates from 1883, and was constructed at the same Lonsdale Avenue site as its predecessor. The company also helped establish the Lonsdale Baptist Church in the 1800s.

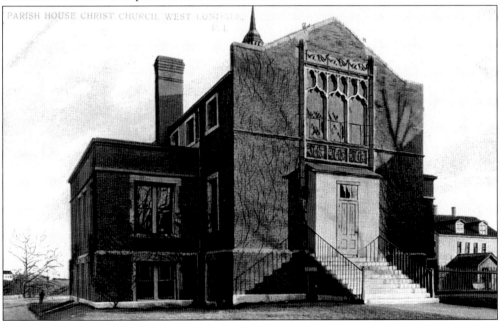

Christ Church parish house has been the site of countless community activities and functions since its construction in 1895. Dancing, bowling, plays, and myriad other recreational activities over the years have provided untold enjoyment to the residents of Lonsdale village.

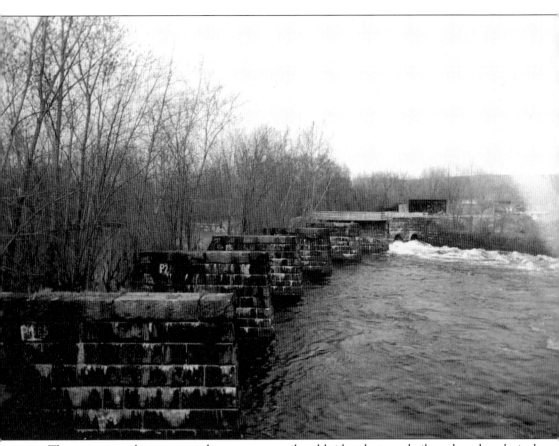

These granite pylons were used to support a railroad bridge that was built and used exclusively by the Lonsdale Company to transport textiles across the river to other parts of the mill complex during various stages of production. The mill's dam, which is visible in the background, and the private railroad bridge were built in the 1800s. The upper deck of the bridge and railroad tracks were removed in the 1950s. Today, the surviving structures associated with the Lonsdale Company are impressive reminders of the village's industrial past.

Six

SAYLESVILLE
AND FAIRLAWN

Colonial settlement of the area now known as Saylesville occurred very early in Rhode Island's history. The Great Road, which was laid out along a well-established American Indian trail, enabled larger numbers of settlers to journey northward from Providence by horse and wagon. One of the first to make that journey was Eleazer Arnold. He built a combined house and tavern along Great Road *c.* 1687. The large stone-ender was considered a mansion in the wilderness, and people in northern Rhode Island traveled considerable distances to marvel at it.

Stephen H. Smith also made the area a destination after he built the Hearthside Mansion. There was nothing quite like it anywhere north of Providence. Smith was also one of the first to build a substantial stone mill in this area of Smithfield at the time.

The history of modern Saylesville began in the 1860s, when W. F. and F. C. Sayles became business partners as well as brothers, and created one of the largest textile and bleachery operations in the country. Like many of the mill owners in Lincoln's other villages, the brothers became very wealthy industrialists, and they contributed heavily to the community that bears their name. They established a church, post office, and fire department. The partnership also constructed unique mill housing in diverse styles, built a community center (Fireman's Hall), and provided their operatives with other social and commercial infrastructure essential to a well-rounded community.

The Fairlawn district evolved as a suburban offshoot of both Saylesville and the city of Pawtucket. Even so, it is important to note that significant structures and history are associated with Fairlawn, and the district rightfully shares in much of Saylesville's origin and history.

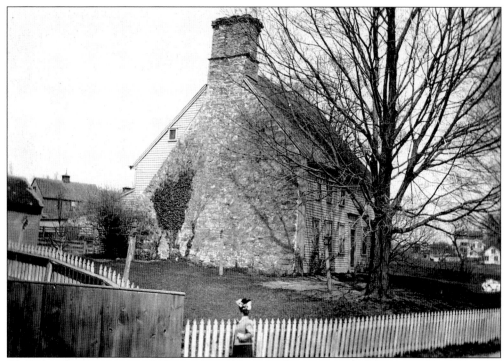

The magnificent mansion of Eleazer Arnold has stood on Great Road for more than 300 years. This 1890s photograph of the house shows the stone end and great chimney of this early-Colonial home and tavern. Eleazer Arnold was one of the first settlers of Smithfield, and he could well be described as a founding father of the area. Arnold, his children, and their relatives were the first ones to carve homesteads out of the wilderness of the North Woods of Providence.

This closeup of the decorative stone masonry of the Arnold mansion's great chimney shows the extensive amount of work that must have gone into constructing it. Three men share credit for building the chimney. The first gentleman who worked on it died after laying only a small section. A second man picked up where the first had left off, but by coincidence he, too, died before the project was completed. What must have been a very apprehensive third mason completed the chimney, leaving us with this beautiful example of Colonial stone-end masonry. Few such buildings have survived into the 21st century.

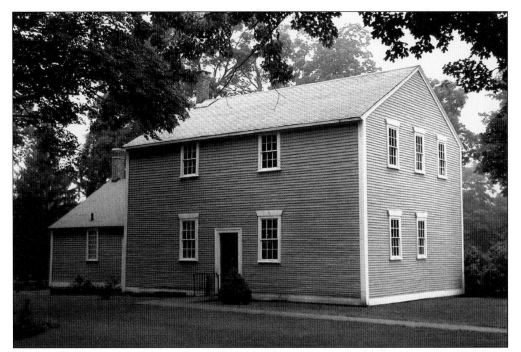

The Quaker Meeting House on Great Road has been in continuous operation for 300 years. The old wing of the meeting house was built in 1703 on land eventually donated by Eleazer Arnold. The Society of Friends has enlarged the structure over the years. Early in its history, the meeting house was called the Providence Meeting House, due to the fact it was the primary gathering place for Quakers in this portion of the state, and present-day Lincoln was part of Providence until 1730.

This interior photograph of the Quaker Meeting House on Great Road shows the staircase and primitive post-and-beam construction of the Colonial building. Each beam of the meeting house was created from a round tree trunk that was squared by hand, using a left- or right-handed broadax. The staircase also has a trip step of unusual height. Tradition indicates these steps were installed to trip intruders. Stephen Hopkins, future signer of the Declaration of Independence and governor of Rhode Island, was married in this meeting house on January 30, 1755.

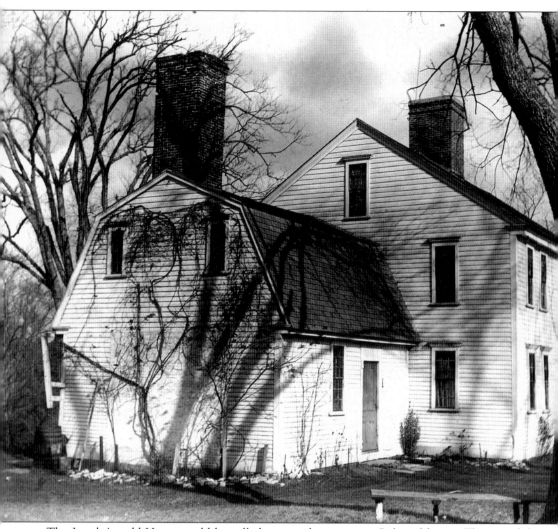

The Israel Arnold House could be called a second-generation Colonial home. The era of the stone-ender was over. The small ell in the foreground of the photograph was built c. 1700. The large part of the house was added about 1750. The home has the largest fireplace in all of Lincoln—20 people can stand within it. The large addition has nine fireplaces, one for each room. So many Arnolds resided in this part of Saylesville that in the early days it was called Arnoldia, and less frequently, Arnoldville.

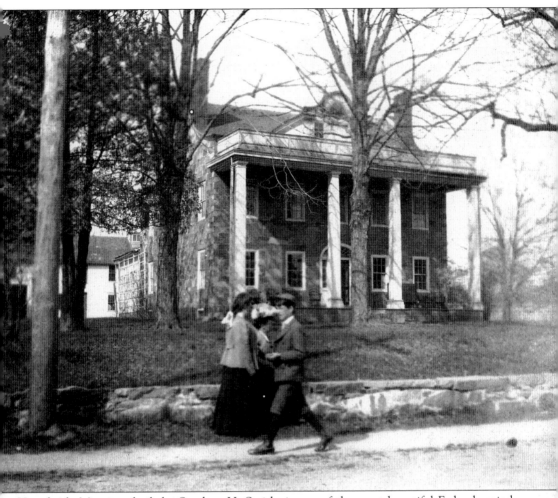

Hearthside Mansion, built by Stephen H. Smith, is one of the most beautiful Federal-period homes in the state of Rhode Island. A recent study commissioned by Friends of Hearthside concluded that the Georgian Colonial–style mansion was constructed between 1810 and 1812. These dates were determined through an exhaustive study into Smith's life, his whereabouts, inheritances, and more. The image above is a photo of the house as it appeared in 1910.

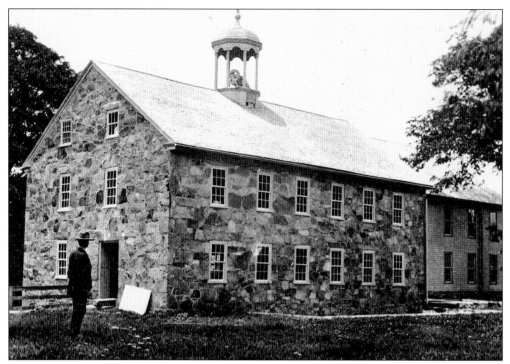

The *c.* 1812 Butterfly Factory was an impressive early textile mill. Quarried stone was the building material chosen by Stephen Smith. The two-story stone mill assumed its name because two prominent butterfly wing–like stones were set side by side during the construction of its exterior walls. No one knows if the effect created was deliberate or not. The Butterfly Factory was originally a cotton mill, but the structure was adapted for other uses in later years.

This photograph shows the Butterfly Factory as it appeared after a roof collapse in the late 1940s. In its last days of commercial use, the factory had housed printworks and a riding academy. During extensive renovations of the building in February 1948, ceiling joists had been removed, and the roof was not properly supported. The weight of a winter snowfall caused the factory's roof to collapse. The unusual mishap was documented in this rare photograph.

This is a late-20th-century photograph of the Olney family homestead. This image was taken in the aftermath of a fire that gutted the historic home. The impressive house was located in what is now Carriage Heights. George Olney and his descendants contributed in many ways to the late-Colonial and early-Federal development of Great Road and the area that would be known as Saylesville.

Most of the Lincoln Woods Reservation contains pristine forest, ponds, and glacial rock formations left behind from the ice age. In this 1940s photograph, giant granite boulders can be seen protruding from the peaceful surface of Olney Pond. The area contained within Lincoln Woods was an annual wintering spot for King and some of his Wampanoag tribe. Sachem's Rock, located at the edge of the north bay of Olney Pond, is where the native king is supposed to have held court in the mid-1600s.

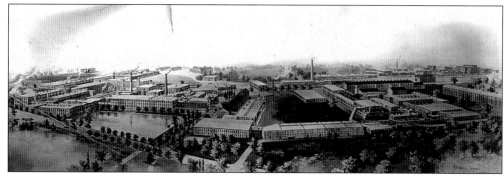

The subject of this c. 1920 illustrated image is the Saylesville mill complex. The Sayles brothers' manufacturing and bleachery operations extended literally as far as the eye could see. In addition to the jobs their company created, W. F. and F. C. Sayles built a community hall (Fireman's Hall), the Memorial Congregational Church, the post office, and streets of diverse mill housing.

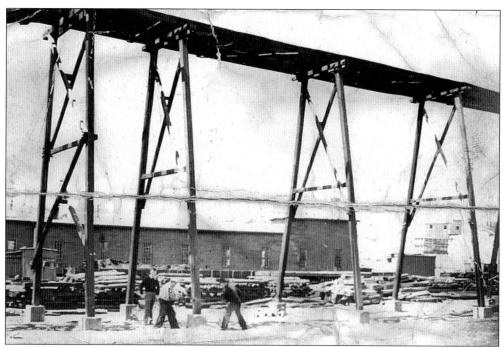

In 1938, the Sayles Finishing Plants hired Stephen Strezsak (left) and his brother-in-law John (center) to dismantle the mill's trestle. The gentleman farthest to the right is an unidentified worker. This photograph was taken in the Sayles mill yard during the first stages of this very challenging and dangerous task.

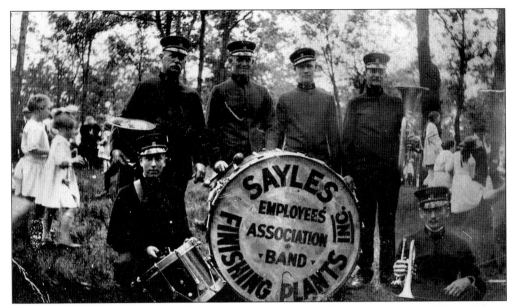

Saylesville also produced a group of brass musicians called the Sayles Finishing Plants Employees Association Band. At least three of Lincoln's villages produced their own bands to perform at town parades and gatherings. The mill happily sponsored village social and civic groups. The company also published the Sayles News, its own publication about employee, social, and business activities.

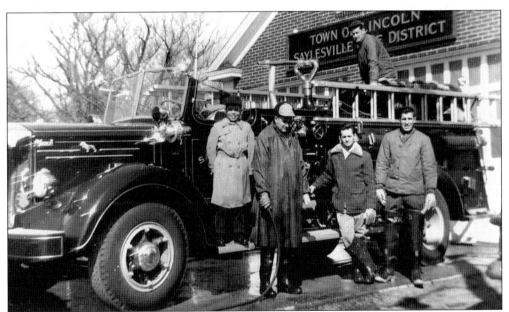

One year after the village of Lonsdale established its fire district, the Saylesville Fire Association was formed. For obvious reasons, the mill assisted in this effort also, and in 1883 Saylesville had a fire department. This photograph was taken in front of the Saylesville fire station in the 1950s. The station has since been enlarged. Shown standing are, from left to right, John "Jack" McDevitt, Napoleon "Nap" Jacques, Bill Lincoln, and an unidentified man. Harold Andrews is on the truck.

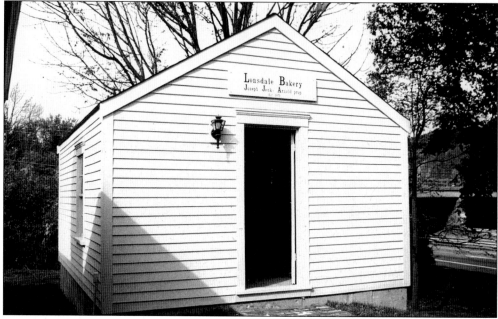

The original wooden Arnold's Lonsdale Bakery building was facing demolition in the 1990s. The larger bakery building on Chapel Street had been demolished years before. The Blackstone Valley Historical Society had the original bakery carefully dismantled and moved. This present-day photograph shows the reconstructed bakery as it appears today. Fully restored, it is now located on the grounds of the North Gate Toll House in Lime Rock.

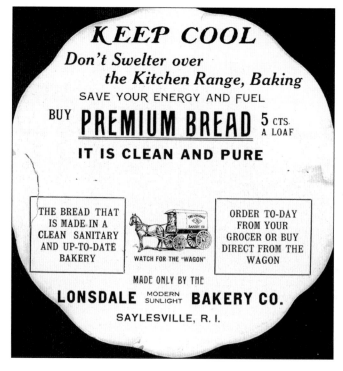

The Arnold's Lonsdale Bakery Company had relocated to the bustling mill village of Saylesville around 1906, and enlarged the new bakery in 1915. Saylesville continued to be the home of what came to be known as Arnold's Bakery for almost 100 years. Shown here is the back of a c. 1906 advertisement fan encouraging customers to "look for the wagon."

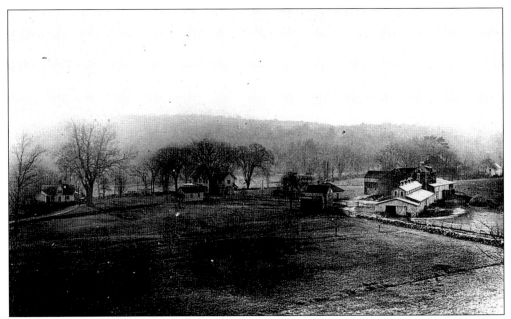

This is an early-20th-century view of Chase and Butterfly Farm as it appeared from the vantage point of today's Butterfly garden. Pictured at the far left is the Chase family farmhouse. To the right is the cow barn, horse and hay barn, and the pair of original wooden farm silos. Chase and Butterfly Farm operated a very large and well-known dairy business at the farm for more than a generation.

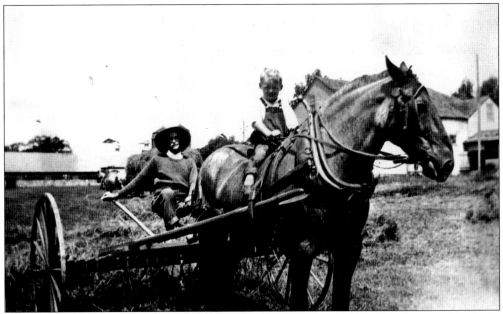

The Chase family purchased Butterfly Farm and combined it with its own farming operations in the late 1920s. The farm then became known as the Chase and Butterfly Farm. Sitting on the farm's horse-drawn hayrake is Charles Chase. His young grandson Ralph Chase is sitting on the horse. The photograph was taken in the early 1900s.

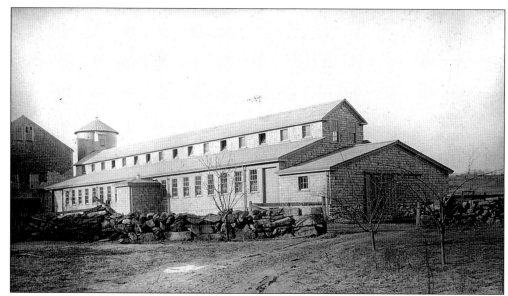

This is a closer view of the barns and silos of Chase and Butterfly Farm. In 1979, Gladys Chase, Benjamin Chase's widow, sold the farmhouse and land to the town of Lincoln as part of an open-space purchase. That farm is now Chase Farm Park. The rolling hills and pastures of the park are used for town recreational activities such as Civil War encampments and battle reenactments, outdoor concerts, and other public events.

Burton Stallwood has the distinction of having been Lincoln's longest-serving town administrator. During his nearly three-decade-long tenure, housing development had begun encroaching on historically sensitive and scenic areas of Lincoln. With an eye toward the preservation of the town's rural atmosphere, Stallwood's administration oversaw the public acquisition of critically important open space and historical landmarks. Among these large open-space purchases were the Chase Farm, Hearthside and its grounds, and the Capt. Valentine Whitman Jr. House.

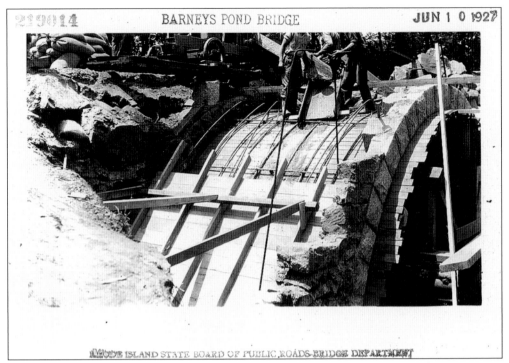

As trucks and automobiles began to push aside horse-drawn transport, the state began to assess the condition of the town's bridges. Many needed reinforcement, widening, or replacement. In this 1927 photograph, state masons can be seen reconstructing the Smithfield Avenue stone-arch bridge. The image is a rare look at the very construction techniques that have left Lincoln with so many beautiful granite-faced arches.

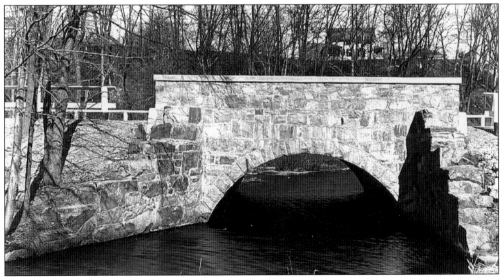

This late-1920s photograph shows the end result of the Smithfield Avenue stone-arch bridge's reconstruction. The original granite facing was reset into place, leaving the bridge's historic appearance intact. Modern guardrails near the approach of the bridge were added in more recent years, replacing the wooden ones that appear at the left side of the photograph.

113

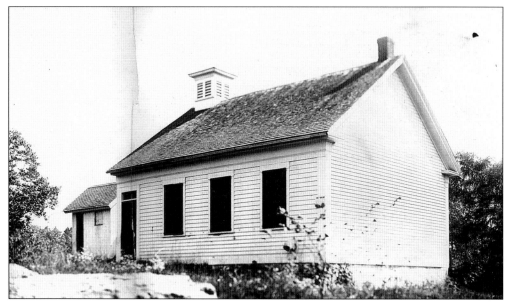

This is an early-1920s photo-postcard of the c. 1850 one-room Moshassuck school on Great Road in Saylesville. It is now a private home. Modern additions have made it almost impossible to recognize as a former Lincoln school. New uses were found for most of the older schools in Saylesville and Fairlawn as well.

When the first community school closed its doors, it, too, was converted into a residence, complete with an adjacent business. This is a 1934 photograph of the Randall's Shell station located on the grounds of the old school at the corner of Louisquisset Pike and Cobble Hill Road. The Randall family moved into the schoolhouse, and opened one of the area's first filling stations on the adjacent lot. The old school remains the Randall family residence.

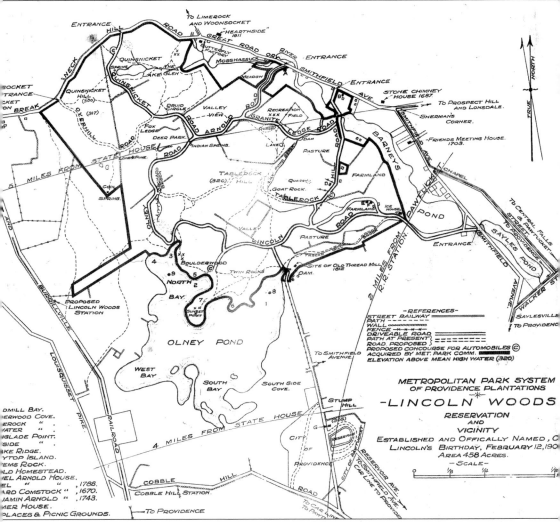

This original 1909 map shows Lincoln Woods Reservation and local points of interest. The park was established and dedicated on Lincoln's Birthday of that year. Much of the acreage of the Olney family, including the old Thread Mill, millhouses, and Olney Pond were incorporated into Lincoln Woods, and became part of the Metropolitan Park System of Providence. A number of homes and at least two mills are attributed to, and in some cases definitely are the creations of, George Olney. The Olney family had extensive holdings in the area of Lincoln Woods, including Olney Pond, which still bears the family name.

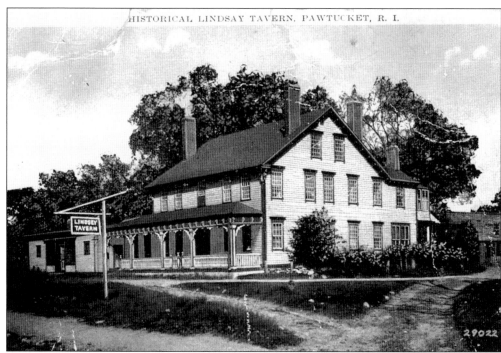

The *c.* 1820 Lindsey Tavern of Fairlawn had both a respectable and notorious past. A variety of owners ran both reputable and questionable operations there over the years. Despite its overall popularity as a fun place, Lindsey Tavern's long history includes lurid tales of adultery, heartache, murder, and tragedy. Its last owner died in a fire that destroyed the building.

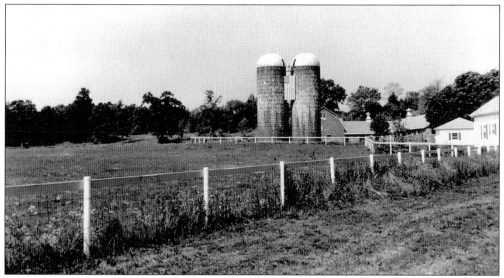

Saylesville's Great Road historic district is a time capsule of the town's Colonial, Federal, and Victorian history. The area has often been referred to as a treasure house of antiquity. Preserved just a short distance from the Sayles brothers' former manufacturing center are the silos of Butterfly Farm, historic homes, green hills, and acres of pasture for the future residents of Saylesville and Lincoln to enjoy.

116

Seven

CENTRAL FALLS

No history of Lincoln would be complete without including Central Falls, which was at one time the town's most developed and populous village. The community itself was originally called Chocolate Mills due to the presence of an early chocolate manufacturing operation. Prior to that time, the area was well known and traveled by local American Indians and was the site of one of the bloodiest battles of King Philip's War.

After hostilities ended, settlers returned to the area once again. Rebuilding started to take hold at the lower falls (Pawtucket), and spread northward during the 18th century. Stephen Jenks established a trip-hammer shop in 1763, and Charles Keane commissioned what is likely to have been the first wooden dam in the village. In time there were a number of enterprises, including that of Mr. Wheat, whose popular chocolate mill gave the village its first name. Snuff mills, blacksmith shops, and other small business ventures began to operate, and soon a village settlement was thriving.

In the 1820s, community leader Stephen Jenks publicly announced that the village would from that day forward be called Central Falls, and not Chocolate Mills. He made the historic announcement at festivities dedicating the new Cross Street Bridge.

When Lincoln became a town in 1871, the heavily settled village of Central Falls contained about 66 percent of the entire town population. Though it was the seat of Lincoln's town government and had the highest population, Central Falls met increasing resentment from residents of Lincoln's rural villages, who bore the cost of maintaining Central Falls' urban infrastructure. By 1894, feelings on both sides were very strong. The Lincoln Town Council took up the matter and made a proposal to the general assembly for a voter referendum on the division of the town. The vote was taken on February 27, 1895.

Within Central Falls, the question tied with 749 votes for and 749 votes against. In Lincoln's other villages the vote was largely in favor of separating Central Falls from the rest of the town. By mid-march, Central Falls was Rhode Island's newest city, complete with a mayor. Central Falls continued to develop a strong industrial base, guaranteeing the future survival of the city.

Barely a little more than one square mile in size, this former urban village of Lincoln has many beautiful and historic structures, not the least of which are the splendid 19th-century Coggswell Memorial Clock Tower, city hall, and numerous public buildings and churches.

On March 26, 1676, Capt. Michael Pierce and most of his men were massacred here along the banks of the Blackstone River, in the bloodiest battle of the American Indian uprising called King Philip's War. The natives watched Pierce's party approach from Dexter's Ledge, the current site of Coggswell Tower. An ambush by the natives forced the English to cross the Blackstone River and emerge here, only to find more natives waiting. Pierce and all but a handful of his men were killed.

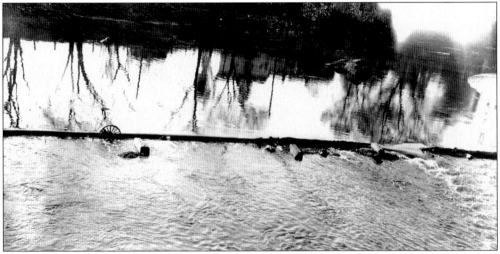

After King Philip's War, settlers eventually returned to the Central Falls area. The c. 1780 wooden dam in Central Falls was built for Charles Keane's water-powered mill. The mill produced metal sharp-edged tools. Keane allowed a portion of his mill to be used for the production of chocolate, which is how the village came by the early names of Chocolate Mills and Chocolateville. In this 1936 photograph, the remains of the dam were still visible when the river's water was drawn out above the Stafford Dam.

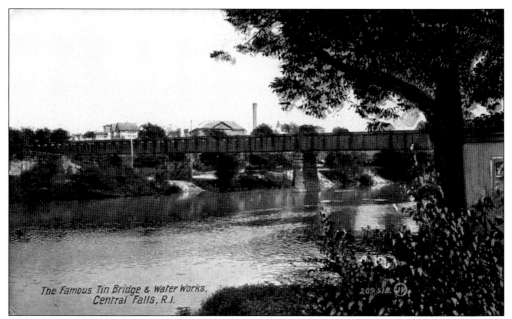

In this illustrated postcard scene from 1910, the Blackstone River can be seen flowing under the old Tin Bridge near Central Falls. Like many early mill villages, Central Falls was attractive for industrial development mainly because of its location near America's hardest-working river, the Blackstone Canal, and later the railroad.

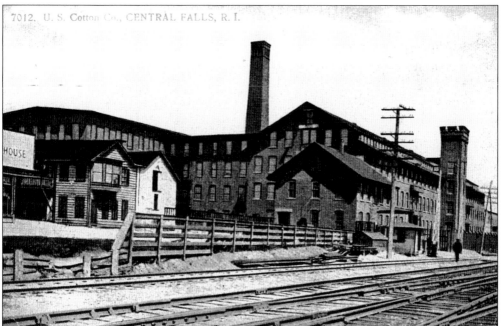

The U.S. Cotton Mill was just one of the many textile mills that put the village of Central Falls on the map. The village's first cloth mill was built in 1825. Through the 19th century, textiles would be king, and thousands of people descended on this community in search of employment. Other villages in Lincoln had one or perhaps two large mills. The village of Central Falls, by comparison, had 17 by the mid-1800s.

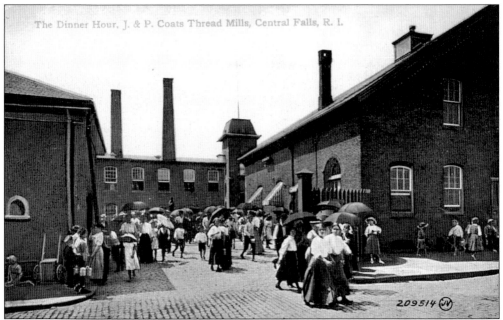

Workers are seen leaving the J. & P. Coats Thread Mills for a half-hour dinner break in this image taken from an early-20th-century illustrated postcard. Mill operatives were expected to work 12- and 14-hour days, six days a week. They were given one half hour for lunch and one half hour for dinner. The work was hard and physically uncomfortable.

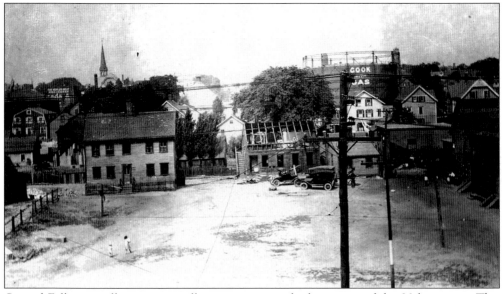

Central Falls was still attracting mill construction at the beginning of the 20th century. This view of the bowery section of the city was taken by George E. Shaw just prior to the construction of the Pennsylvania Textile Mill on Mill Street. Though it appeared this way in 1920, the bowery used to be called Tingley's Meadow in the mid-1800s.

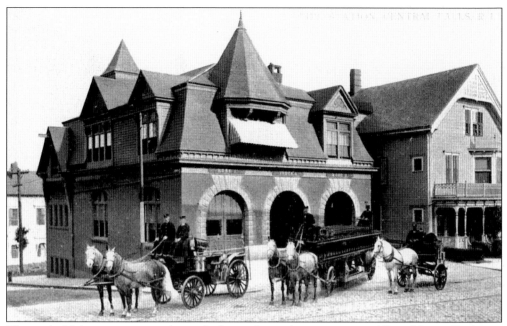

This early-20th-century scene shows the horse-drawn fire apparatus and Broad Street Firehouse of the Central Falls Fire District. More heavily populated and developed than any of Smithfield's other mill villages, Central Falls was given the state general assembly's endorsement for the creation of a village fire district in 1847. This act allowed Central Falls to collect taxes and provide local services. The citizens of this village paid taxes to Smithfield and later Lincoln as well.

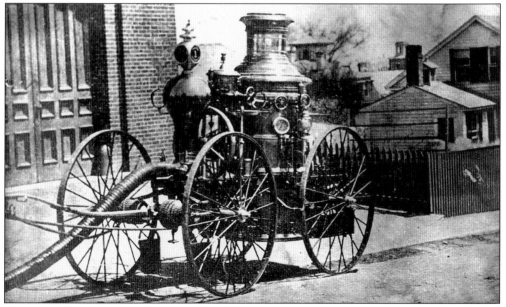

The steam fire engine *Pacific* was purchased by the Central Falls Fire District in 1871, the same year Central Falls became a village of Lincoln. The first steam-powered pumper was considered to be state-of-the-art equipment at the time, and village firefighters were happy to do away with the previous pumpers that had to be operated by sheer muscle.

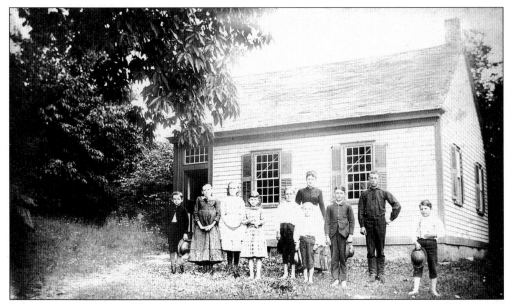

Prior to the 1850s, the village of Central Falls had a north and a south schoolhouse. The original schools no longer exist. The building in this c. 1880s photograph shows a distinct similarity to the one-room schoolhouses in other parts of Smithfield. The school depicted here is likely the North School, which was located at the rear of Central Street, midway between Mill and High Streets. This image was photographed by William O. Read of Central Falls.

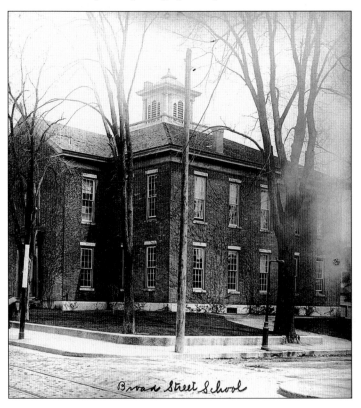

Broad Street School

This late-1800s photograph shows the new Broad Street School, which was built by the town of Smithfield in 1861. Located at the corner of Broad and Cross Streets, the large school only met the needs of Central Falls' children for about 15 years. By the 1880s, a new town of Lincoln saw the need for an addition. Even under crowded conditions, the new school was a vast improvement over the little schoolhouses, and it provided district children a chance to get a full education from elementary school through high school.

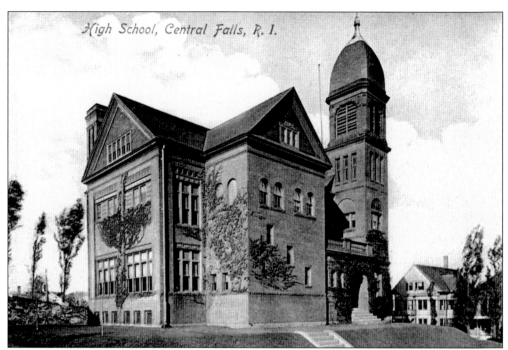

The building depicted in this early-1900s printed postcard was Lincoln's, and later Central Falls', first true high school. The 1889 brick building and its impressive tower were built the same year as the Broad Street Firehouse. The municipal building boom of this period reflected the village's growing success as a major manufacturing center. When a more modern high school opened in 1927, the city abandoned the old Lincoln town hall, and moved city government offices to this building. It remains Central Falls' city hall to this day.

Many stately historic homes have been built in Central Falls. This is a 1904 view of the 19th-century Horace Daniels House as it appeared at the corner of Broad and Cross Streets. Horace Daniels could rightly be called a leading citizen, as well as a mill owner. Although his largest manufacturing partnerships were located in Pawtucket, Daniels preferred to live in his hometown of Central Falls. The grand home was later occupied by D. G. Littlefield. Embedded in the cobblestone-paved road in the foreground are the Broad Street tracks of the Providence, Pawtucket, and Central Falls Railroad Company.

Compared to the previous photograph, the streetcar tracks are more visible in this view of the opposite corner of Broad and Cross Streets. The line provided horse-drawn streetcar transportation service from 1864 to 1928. This area of Central Falls was considered a prestigious neighborhood. It was primarily occupied by wealthy merchants, doctors, mill owners, superintendents, and other upper management of the large textile companies.

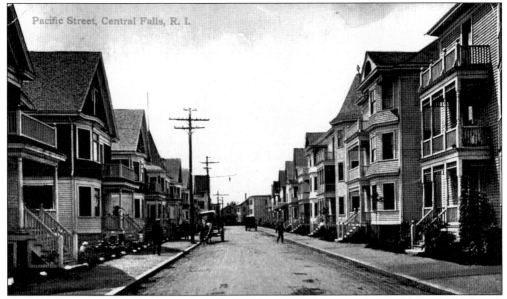

This c. 1912 view of Pacific Street shows the stark contrast between the wealthy neighborhoods and those of the typical mill operative. Double- and triple-decker tenement housing were everywhere in the working-class areas of the city. At the time of its separation from the town of Lincoln, Central Falls housed about two-thirds of the town's population. Except for the antique vehicle in the roadway, the appearance of these neighborhoods remains basically unchanged today.

As countless French Canadian mill operatives began to move into Central Falls, they brought their Catholic faith with them. Notre Dame Parish was established in 1873 by local parishioners and Father Charles Dauray. The first Notre Dame Church, pictured at right, was constructed on Fales Street in 1875. The original was torn down and a new church was built in 1933. The congregation chose a different property on Broad Street for the new church. Notre Dame has the distinction of being the first French-speaking parish established in the state.

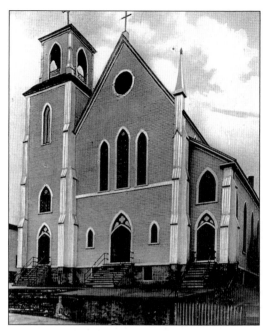

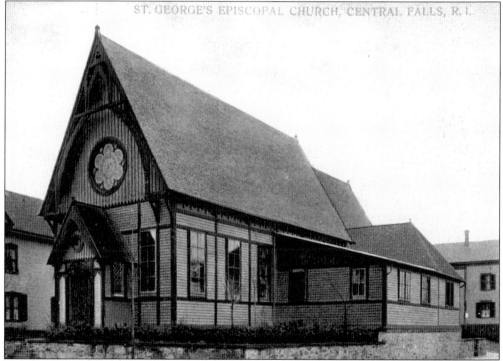

Central Falls has been the home of numerous churches throughout its history. Shown in this c. 1910 illustrated postcard is the original St. George's Episcopal Church. English mill workers had formed the parish in 1865, and they erected this church in 1874. The congregation eventually outgrew this building, and in 1922, a new and larger St. George's Church was constructed. The congregation saved the original church's rose window, and installed it in their new Gothic-style church on Clinton Street.

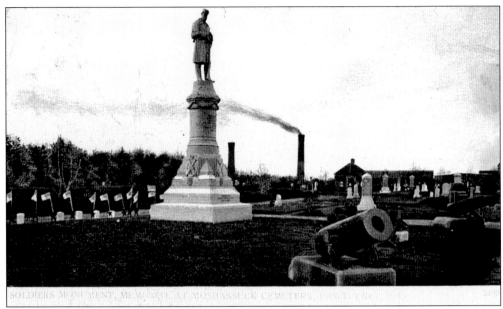

In 1888, the Ballou Post of the Grand Army of the Republic unveiled this striking granite statue in honor of Central Falls' Civil War heroes. A lone soldier holding his rifle stands at the top of this monument in the Moshassuck Cemetery on Lonsdale Avenue. The official name of the monument is the Soldiers and Sailors Memorial. During the violent labor strikes of the early 1930s, workers from Lincoln's nearby Saylesville Bleachery skirmished with Rhode Island National Guard troops within the walls of this cemetery.

The Adams Free Public Library on Central Street was constructed in 1910. It was a gift to the city from Stephen L. Adams. The Central Falls Fire District had been responsible for maintaining the community's public collection of books before this brick-and-limestone edifice was built. Since 1882, the books had been stored at the Cross Street Pacific Fire Station Company. The city's books finally found a new and permanent home in this magnificent historic library.

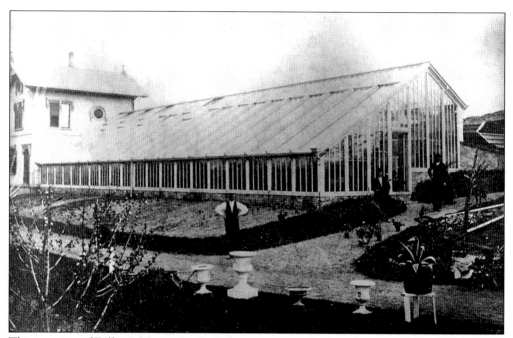

This is a view of Follett's Mountain Greenhouse as it appeared in the early 1880s. Although the village of Central Falls was becoming more urbanized, one section remained green. At the top of the ledge in Jenks Park was the Mountain Greenhouse. John H. Follett operated this huge greenhouse on the Jenks estate until 1890.

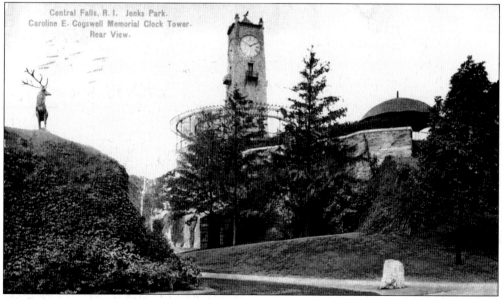

Of all the historic landmarks of Central Falls, Jenks Park and the Coggswell Memorial Clock Tower are two of the most recognizable. This is a less familiar c. 1904 rear view of the park and tower. Open land was a very valuable commodity in the village of Central Falls. Despite its value, Alvin Jenks donated the four acres of open space to the town of Lincoln in 1890. His only request was that the property be used to preserve the memory of his family, who had been so instrumental in the prosperity of the village.

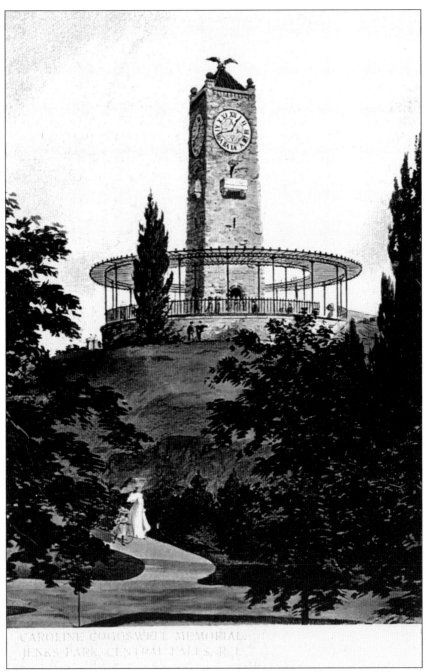

CAROLINE COGGSWELL MEMORIAL.
JENKS PARK, CENTRAL FALLS, R. I.

An enormous eagle once graced the top of the Caroline Coggswell Memorial Tower in Jenks Park. The carved statue is clearly visible in this early-20th-century illustrated-postcard image. The huge stone clock tower was given to the new city of Central Falls by Caroline Coggswell in 1904. It stands on Dexter's Ledge, the exact spot where American Indian lookouts saw the approach of Captain Pierce and his men in 1676. The 100-year-old tower has come to symbolize the fortitude of this former village of Lincoln that became a city.